Alfred Wallis

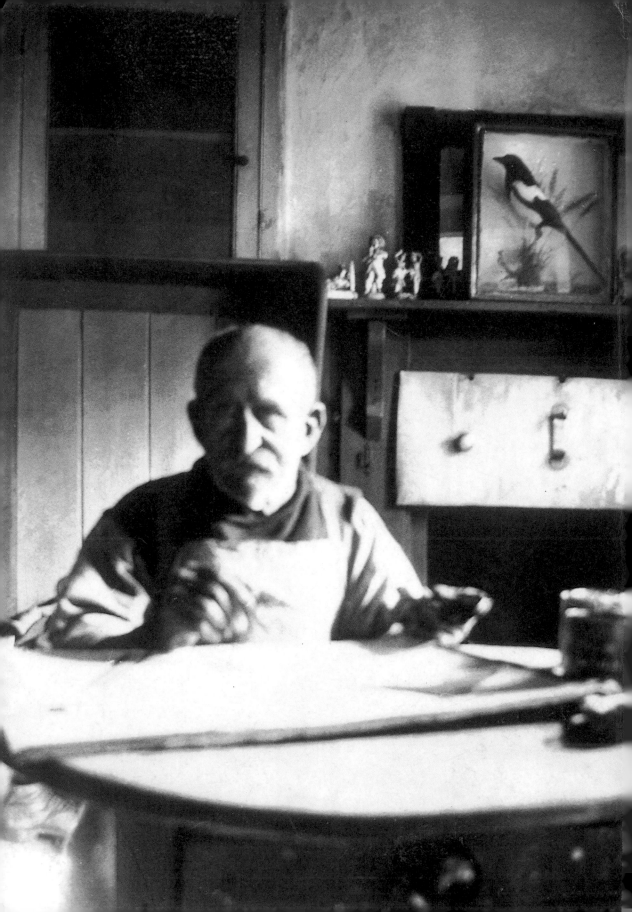

Alfred Wallis

Matthew Gale

ST IVES ARTISTS

Tate Gallery Publishing

cover:
Schooner under the Moon c.1936 (fig.43)

back cover:
Wallis at the door of his house *c.*1940

fig.1 (frontispiece):
Alfred Wallis painting at 3 Back Road West,
St Ives in 1928. Tate Gallery Archive

ISBN 1 8547 228 9

A catalogue record for this book is available
from the British Library

Published in 1998 by order of the Trustees of
the Tate Gallery by Tate Gallery Publishing Ltd,
Millbank, London SW1P 4RG

Matthew Gale has asserted his right
to be identified as the author of this work

Cover designed by Slatter-Anderson, London
Book designed by Isambard Thomas

Printed in Hong Kong by South Seas
International Press Ltd

Measurements are given in centimetres, height
before width

St Ives Artists

The light, landscape and working people of
West Cornwall have made it a centre of artistic
activity for over one hundred years. This series
introduces the life and work of artists of national
and international reputation who have been
closely associated with the area and whose
work can be seen at Tate Gallery St Ives. Each
author sets out a fresh approach to our thinking
about some of the most fascinating artistic
figures of the twentieth century.

Acknowledgements

As well as the authors of the works mentioned
in the Introduction, I should like to thank the
following for their help and their insights into
Wallis's work. All those interested in his work
owe a debt to the Wallis scholar Roger Slack;
the revelations of Peter Barnes's work came
just in time and I am grateful to him for his
openness and enthusiasm. In St Ives, I was also
able to draw upon the memories of Stanley
Cock, formerly of the St Ives Museum, and on
those of the members of the Fisherman's
Lodge, including Frank Bottrell and Dick
Pollard. Few of the original artist-collectors of
Wallis's work survive, but among them I should
like to thank Jack Hepworth and John Wells; to
these I should add thanks to Jane Mitchell and
Sheila Lanyon. A number of others whom I
should like to thank have been instrumental
both knowingly and unknowingly: these include
my former colleagues at Kettle's Yard in
Cambridge, especially Paul Allitt, Sarah
Glennie and Michael Harrison; Claire Bishop,
who undertook the last-minute research on
some abstruse details; my colleagues at the
Tate Gallery in London, including Sandy Nairne,
who made incisive comments about a first
draft, Mary Bustin, who has offered valuable
insights as a result of her technical
investigation of Wallis's paintings at the Tate,
and especially Chris Stephens, with whom
many of the wider issues have been discussed
and who has also commented on the text. I
should add thanks to those at Tate Gallery St
Ives, including Norman Pollard and Matthew
Rowe, and especially Mike Tooby, for giving me
the opportunity to explore the ideas in some
depth. Celia Clear and Judith Severne at Tate
Gallery Publishing have been encouraging
throughout. Finally, I would like to thank my
parents and family, as well as my wife, Rowena
Fuller, who stood in Wallis's doorway in order to
estimate how short he really was.

Contents

Introduction

Alfred Wallis was unusual among retired fishermen because, for nearly twenty years, he painted six days a week. These were the years in St Ives, Cornwall, from 1925 until his death in Madron in 1942, at the age of eighty-seven. In bringing the experience of life at sea and in port into the realm of art he confounded expectations and crossed social divides. There is little sense in which he set out to do this; he painted, he said, 'for company', after the death of his wife. However, the fervency and vigour with which he translated his experience into paint, secured his recognition by a small band of avant-garde painters and writers in London. They perceived in his work a raw directness, associated with his lack of training as an artist, which earned him the ambiguous epithet of 'primitive painter'. For some, his painting was a brief vogue and Wallis a fashionable mascot, but for his most serious collectors, especially among painters, his work exposed a creative energy unhindered by learned conventions. This was a state to which they too aspired.

Since his death several accounts have been available of the life and work of Alfred Wallis. Nevertheless, he continues to be treated as a cipher – a *tabula rasa* – onto which the ideas and perceptions of others have been cast. This is not uncommon, especially if an artist's writings on their own work are ambiguous. Whilst Wallis's writings – in the form of letters to his artist friends and patrons – have special qualities, they must be acknowledged as inadequate discussions of the paintings. Very few even provide a descriptive list of the works that they accompanied, and the suggestions of methods and approaches are merest hints. This is to be expected, as he evidently felt that such matters were best left unexplained or were, perhaps, inexplicable. It does not seem to have been the case when he was spoken with in person, but such conversations as there were quickly became garbled in memory. The vacuum of discussion was quickly filled by myth. Biographical hearsay, speculation and assertion have bridged the gaps in the story and coloured the different accounts of his work. Among the resulting tangle, a number of layers may be recognised from which the myth of Wallis has been constructed.

The work was, to a certain extent, mythic even for the painter himself. In his insistence that he painted 'what used to be', he revealed its root in memory. If this was recognised as the sole purpose, his paintings of fishing boats could be seen as the inevitable nostalgia of a lonely, once active, man. In fact, as we shall see, he was not so backward looking or exclusive in his concentration. Alongside the favoured sailing ships appear the steam and motor vessels which superseded them. On land, the repetitive terraced houses of the towns are very occasionally reached by bus, and even aeroplanes and airships make appearances in the sky. It may be argued that these features were outdated by the

1940s, but they hint at a more varied subject matter than that usually acknowledged in discussions of his work.

Despite this evidence, Wallis's nostalgia has bred nostalgia in others. Those who knew him (or knew of him) in the 1930s saw an overwhelmingly heroic struggle on the land and the sea in his paintings, and he came to represent an untainted survival of a lost prehistory implicit in the term 'primitive'. This understanding took on different aspects. Although all old people provided connections to the communal past through the spoken word, Wallis's paintings were potentially direct and tangible links. However, his isolation and his misanthropic behaviour in later life obscured this social service for even his family and neighbours, and his painting was regarded as another manifestation of his eccentricity and even paranoia.

For others who came into contact with his work, he represented something more archaic in a world overwhelmed by modernisation and urbanisation. Artistic and literary patrons from Hampstead in the 1930s found in Wallis the confirmation of the romantic wildness of Cornwall. For these London artists, who sought escape at the land's end, Cornwall was impressively rugged and beautiful. Through the ancient chapels and standing stones it appeared to be authentically rooted in a history which, in the middle of the century, was more and more required as a bulwark against shifting uncertainties. Wallis brought these qualities into focus by painting out of his own experience and what seemed to be that of his forefathers, a timelessness which was reassuring. It is instructive that his work has been compared to that of medieval painters, because the formal parallels (narrative, limited colour, lack of pictorial conventions) disguise a perception of Wallis as a figure mysterious even in his proximity. The possibility that he sailed to America and elsewhere seems as epic as the Arthurian or apostolic journeys associated with the West Country.

Certain points of reference have long been repeated. In 1943, the year after Wallis's death, Ben Nicholson conjured up an impression of the painter's method to accompany Sven Berlin's first article.[1] Whilst adding his own political and psychological interpretation, soon afterwards Berlin gathered in his biography, *Alfred Wallis: Primitive*, the stories of the painter's early life which had been passed down through his family.[2] Twenty years later Edwin Mullins offered a restrained corrective, especially as regards the potential meanings of the work, in his book *Alfred Wallis: Cornish Primitive Painter*, whilst, for the Arts Council exhibition of 1968, Alan Bowness identified locations shown in the paintings which indicated their topographical complexity.[3] Both relied for additional biographical information on the recordings made by Dr Roger Slack in the 1960s of those who remembered Wallis; these tended to corroborate Berlin's findings.

The present account is inevitably indebted to all of the foregoing, but may be distinguished from them in several respects. In beginning to check the dates of Wallis's life in official records, it became apparent that the family stories were unreliable. By extreme good fortune, I encountered Peter Barnes who had already undertaken a thorough search of public records and has been generous in sharing his findings with me prior to the publication of *Alfred Wallis and his Family: Fact and Fiction*.[4] The results, when brought together with the established account, have revolutionised the factual knowledge of Wallis's early life. My second chapter undertakes, for the first time, a detailed reading of the artist's letters written between 1928 and 1939, in order to expose his attitudes to painting and his relationship with his correspondents. This reading provides a

view of his nostalgia, but also his productive diligence. The conclusions of both chapters 1 and 2 inform the discussion of the works themselves in chapter 3. Here I have sought to date and group certain paintings, and to offer suggestions of a developmental view, a tentative attempt at which was made by David Brown in the 1985 Tate Gallery catalogue of the *St Ives 1939–64* exhibition. Many might protest that this is an undesirable or impossible task; Mullins views dating the works as 'a pointless art historical feat'.[5] However, a more historical perspective for the work – however tentative – opens it to other, less linear, means of interpretation and discussion. The absence of such structures in relation to Wallis serves to perpetuate the fundamentally unconvincing notion that there was no change of any significance over nearly two decades – that his ships of 1928 are the same as those of 1938. Furthermore, it may disguise more profound assumptions about the nature of works produced by 'primitive' artists which, at the very least, deserve questioning. The changing context of such assumptions is the subject of the concluding chapter, in which the reception of Wallis's work is seen in the light of mid-twentieth century ideas of the 'primitive'.

It is inevitable that this text will show its age through its concerns. The very fact that it is associated with the Tate Gallery in St Ives locates it within a reassessment of painting in the town undertaken in the 1980s and 1990s. In particular it is coloured by my own experience of Wallis's paintings while working at Kettle's Yard in Cambridge and subsequently at the Tate Gallery in London. However, if this book is able to furnish an argument which remains satisfactory for half of the time of its predecessors, then that may be sufficient.

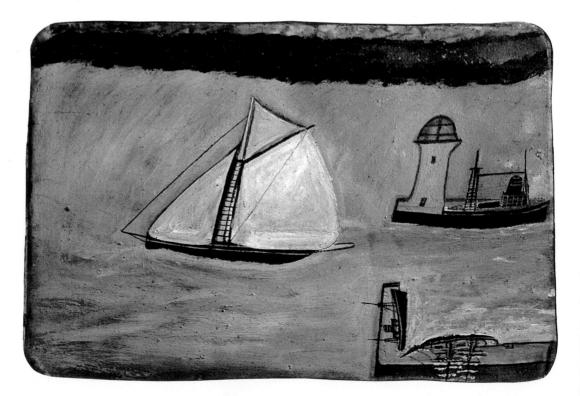

'The fall of Serveserpool'
A Life of Alfred Wallis

Until he began to paint, Alfred Wallis's life was unremarkable for a man of his time. He spent some years at sea as a fisherman, before spending nearly twenty-five years in port as a dealer in marine stores – essentially a rag-and-bone man. He retired before the First World War. What set him apart was the compulsion with which he painted in his seventies and eighties and the nature of the works themselves, which at their best are evocative of the precariousness of all certainties.

In some respects, it is remarkable that so much *is* known about Wallis's life. Admittedly there are long periods for which the details are scant or subject to conflicting claims. The modesty of the man and his activities might be expected to have obscured the rest. Such a fear may have concerned H.S. 'Jim' Ede, one of his most consistent collectors, who appears to have encouraged the painter to divulge biographical information. This was limited to the crucial statement in 1935 in Wallis's idiosyncratic and somewhat portentous language: 'if i live Till The 8 of August next i shall Be 78 years old I was Born in Devenport Born on The day of The fall of Serveserpool Rushan War'. Later he added: 'i was Born at North Coroner Devenport'.[1] Although Sebastopol fell, bringing the Crimean War to a close, on 8/9 September 1855, Wallis had miscalculated his age but was quite correct about his birthday. The official record confirms that he was born on 8 August 1855 to Charles and Jane Wallis (née Ellis) at 5 Pond Lane, Devonport.[2]

The family lived in the working class district outside Plymouth for some years.[3] This upbringing in Devon is sometimes seen as a reason for Wallis later being set apart in the tight-knit community of St Ives. However, new research has shown that his parents had originally come from Penzance and that the family returned there by 1871.[4] Instead, it may be argued that Wallis was predisposed to such a peripheral position as a result of his own characteristics. He was 'a little short chap',[5] possibly only four feet six inches tall. By the peculiarities of his marriage, he inherited a grown-up family. In old age, the period from which most accounts survive, he was also quite deaf and paranoid. These incidental facts conspired to make Wallis an outsider even before he began to paint.

It is likely that Alfred Wallis grew up under conditions of looming poverty with which he would remain familiar. His parents were from Sennen and Madron, the rural communities of West Penwith, and were married at Penzance in 1844.[6] They must have migrated to Devonport in search of work. According to family lore, Charles Wallis enlisted in the military during the Crimean War and missed Alfred's birth.[7] The fascination with the war cannot easily be explained, but Charles was in fact the 'informant' on the birth certificate. This also shows that he was illiterate, only able to make his 'mark', and that he was a 'Hammar [sic]

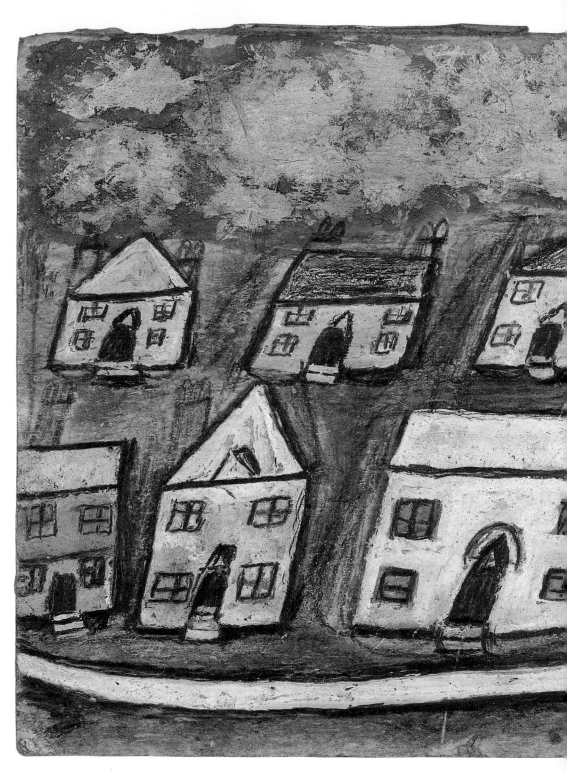

3
White Houses
c.1930–2
Oil on card
14.9 × 23.2 cm
Kettle's Yard, University of
Cambridge

man in a coach factory'[8] Two years before he had been described simply as a 'labourer' on the birth certificate of his older son, also called Charles; an older daughter, Mary, was registered in 1851 but there is no further trace of her.[9]

Charles Wallis's menial work and their periodic changes of address suggest that his financial situation was precarious. Nevertheless, he thought it acceptable, or necessary, to pose for a photographic portrait in his Sunday best. With his John Ruskin sideburns, he did indeed look like a 'Victorian moralist [and] good respectable citizen'[10] Perhaps it was this sense of propriety which led him to ensure that Alfred went to school: the seven-year-old is listed in the 1861 census as a 'scholar',[11] and his later handwriting suggests a decayed Victorian copperplate.

Jane Wallis died at Devonport in early 1866.[12] Charles was listed as a 'street pavior' at the time, just as he had been five years earlier, and this tallies with Berlin's story that he was a 'master paver'.[13] Perhaps because of Jane's death, the family returned to Penzance, where they appear to have taken to basket making, an occupation practised by other Wallises in the town. In 1871, at sixteen, Alfred was an 'apprentice basket maker' living with his father, a 'journeyman mason'.[14]

Five years later, in 1876, he was registered as both a 'sailor' and as a 'mariner, merchant service'.[15] There is now evidence for a trans-Atlantic crossing in that year, as an Alfred Wallis aged nineteen (in fact he was twenty) is on the crew list of the *Belle Adventure*. He joined the ship at St John, Newfoundland, on 7 August 1876 and disembarked on arrival at Teignmouth, Devon on 9 December.[16] This new evidence clarifies the subsequent conflicting stories about his life at sea. On the one hand, it casts doubt on his claim, recalled by his relation Nancy Ward and widely repeated, that he had gone to sea as a cabin boy at the age of nine,[17] although details are still missing for his years between the ages of seven and sixteen. On the other hand, it refutes the recollection of Albert Rowe, who was a boy when he encountered Wallis, that 'Grandfather had told me that Alfred had never been to sea in his life'.[18] On Peter Barnes's findings, Wallis went to sea sometime after 1871 and certainly by 1876, but he registered as a 'labourer' in 1879 and 1881.[19]

Penzance and Newlyn were thriving fishing and trading ports in the middle of the nineteenth century. Indeed, the Cornwall which Wallis knew was passing through the final upheavals of the Industrial Revolution in which new opportunities arose alongside new oppressions. Industrial change was driven by coal brought from the Welsh valleys into every port along the coast. The land was opened up by Brunel's Great Western Railway crossing the Tamar with the impressive Royal Albert Bridge from Devonport to Saltash, a structure which Wallis appeared to paint from memory in the 1930s. The railway brought mobility and social change. It facilitated the departure of Cornishmen and brought in outsiders, from the GWR workers of Swindon (who came on special annual holidays), to the painters who kept studios in St Ives and Newlyn. The landscape was punctuated by the tin-mine pit heads, whilst the treacherous shores were pinpointed by lighthouses built on seemingly inaccessible rocks and promontories. The engineering and manpower required for such projects speak for their importance in the functioning of the Empire.

Wallis witnessed the zenith of the great sailing ships, the schooners and brigantines, which carried most global trade between the 1820s and 1890s. Even the fishing fleet crossed the Atlantic, and the Cornish pilchard catch was shipped to the Italian markets of Naples and Livorno. As a 'mariner, merchant

service' he may have worked on such routes, and the crew list of the *Belle Adventure* confirms his own account – to have crossed the Atlantic in the 'cod bankers' bound for the Grand Banks off Newfoundland. Among his paintings some, such as that called *Voyage to Labrador* (fig.46) and that of a brigantine and inscribed 'Bellaventur of Brixham Larbordoor Newfoundland Ice Burges' substantiate the claim.[20] The crossing was undeniably dangerous, and there is a dramatic story of Wallis's ship being caught in a storm which was only survived by jettisoning the catch.[21] He is said to have given up deep sea fishing for inshore fishing after this, sailing to Scotland and Yorkshire, and working on the Mount's Bay Luggers which concentrated upon seasonal staples: pilchards and herring in winter, mackerel in summer. Although such stories are impossible to verify, Wallis does not appear to have been inclined to boastful exaggeration: he did not claim to have seen tigers in the forests, but he did paint huge fish. Of these Albert Rowe recalled him saying: 'each boat of that fleet had a soul, a beautiful soul shaped like a fish'.[22]

Though life at sea and in port was hard, Sven Berlin gathered accounts of a family fortune. An uncle (possibly Jane Wallis's brother) – or brother –– made a fortune as the 'captain' of a gold mine in Australia – or South Africa. This was left to Alfred's brother Charles – or to a cousin, the grandfather of Albert Rowe.[23] A dispute associated with this garbled story lay behind the Wallis brothers' falling-out. By way of a tantalising aside, it should be noted that in April 1894 a Richard Ellis was reported to have struck a rich gold reef near Coolgardie in Australia;[24] Jane Wallis did have an uncle called Richard (born 1798) but there is no record of her having a brother of that name.[25]

4
Alfred Wallis, ?1890s

During the late 1870s Alfred Wallis's personal life was transformed as he cautiously established a new family base in Penzance. His father may be the Charles Wallis who died in 1878.[26] Two years earlier the younger Charles had married Elizabeth Williams; she – or they – already had an illegitimate girl and the story of Alfred staying with them when he was a bachelor may date from this pre-marital relationship.[27] Apparently disapproving of their drinking, he soon preferred to lodge with the family of a friend, George Ward, in New Street. George's mother, Susan Ward (née Agland), had moved from Madron after the death of her husband. She had been trained in lace making in her native Devon and this skill helped her to provide for her five children.[28] Wallis's contribution to the widow's household must have been a small but essential amount of rent.

On 2 April 1876, Susan Ward and Alfred Wallis were married at St Mary's church Madron; she was forty-three, he was twenty.[29] Various interpretations have been placed upon this rather surprising turn of events, which made Alfred the step-father of his friend George. It has been suggested that it was demanded by propriety, if Wallis wanted to remain lodging with a young widow.[30] Although Susan was reputed to be strictly religious, this would seem excessively cautious given the age difference. Some urgency was added by the fact that she was pregnant and bore a son, Alfred Charles, on 5 July. As Wallis was in Newfoundland a month later, he may have missed the birth, and certainly missed the child's death in September. A daughter, Ellen Jane, born in May 1879, died

fifteen months later.[31] Sven Berlin proposed a psychoanalytic interpretation of the son marrying the mother in a classic illustration of Sigmund Freud's Oedipus complex.[32] There may be something in each explanation; the age difference was certainly remarkable, and it seems likely that Wallis was 'mothered'. In hindsight, and on perhaps very little evidence, Nancy Ward suggested that Susan had married him 'out of pity', although she added (this time out of her own experience) that 'they were very happy together'.[33] The deaths of the couple's own two children added a further pressure to an already complex relationship.

They continued to live in Penzance for about ten years after their marriage. For most of that period, Wallis was simply a labourer. His brother Charles Wallis was a 'marine stores dealer' in Penzance trading in salvaged equipment and material, with which Alfred may have helped. According to Berlin, the business was owned by a Mr Joe Denley – characterised as a shabby but hard businessman – who asked Alfred Wallis to set up a similar store in St Ives.[34]

In 1887 Albert Ward, the second step-son, married Margaret Ninnis of St Ives. Allowing time for Alfred, Susan and the Wards to settle in and Jacob to go courting, Peter Barnes has speculated that the family transfer to St Ives was made around 1885.[35] Wallis had established his Marine Stores in Back Road by 1887, but in the 1891 Census their residence was Bethesda Road, which seems to be the 4 Bethesda Hill address given by Berlin.[36] They must have witnessed the work on extending the nearby Smeaton's Pier – doubling its length and its lighthouses – which was completed in the summer of 1890. By 1902, they had moved the stores to the next street closer to the pier with a frontage on the Wharf.[37] This establishment, with its outside stair to the first floor, appears in several photographs (fig.5). It is identified by Wallis's higgledy-piggledy hand-painted sign, which reads: 'A WALLIS DEALER IИ MARINE STOES'. The building has been refaced, but the side street is still recognisable; it seems to have lost its name, although some recall it as Murley's Lane.

Wallis's Marine Stores are relatively well documented. They may have supplied basic equipment (rope, nails, paint), but mostly dealt in secondhand and salvaged goods. Wallis collected supplies in a small cart taken around the town,

5
Wallis's Marine Stores
in the Wharf, St Ives
after 1902
Tate Gallery Archive

6
Wallis (second from
right) and others on
the Wharf, St Ives
after 1902

where his rag-and-bone-man's cry 'Old Iron' became his nickname. Other supplies were gathered by local boys. Thomas Lander recalled: 'As boys we used to go on the beaches and collect small quantities of rags and bones. But they had to be clean … if he said "tuppence" it was tuppence … He was a quiet man, an industrious man'.[38]

This industrious man was ably assisted. A neighbour Ellen Bryant did the book keeping and what correspondence there was.[39] Curiously, an envelope survives from a letter sent to Wallis at The Wharf by the London firm of hatters, Sennett Bros.[40] Susan minded the store and packed up the goods in preparation for the fortnightly arrival of Joe Denley's agent, Mr Gilbert. Wallis would accompany Gilbert's two carts on the trip to Penzance with his own cart. He walked there and back, often travelling at night, presumably as it was out of trading hours and saved him the price of a bed. He was touchingly fond first of his donkey and then his pony.[41]

It is difficult to get a balanced picture of the rag-and-bone-man in the 1890s. He was not the deaf truculent old man whom some still remember. In an early photograph he appears quietly melancholic, although this could easily result from the long photographic exposure (fig.4). Other uncertain identifications of him survive. In one photograph, a tiny figure in a white smock stands beside Wallis's cart on The Wharf: this has been presumed to be him.[42] Another, taken nearer the Sloop Inn, includes a man in a bowler hat and with a drooping moustache who is identified as Wallis by the artist Andrew Lanyon (fig.6). He is unexpectedly debonair and fits more with Thomas Cothey's recollection of a 'dapper little man … [who] thought all the girls in St Ives were after him'.[43] The identification is open to doubt but it remains an attractive prospect that this is Wallis relaxing. Against the picture of the essentially melancholic man, this photograph balances another, perhaps equally unreliable: a man who, with a business and family in a hard-working community, was (occasionally) content with his lot.

The Marine Stores must have been relatively successful in the 1890s, but one incident surfaces which offers a glimpse of the business. In 1894, Wallis

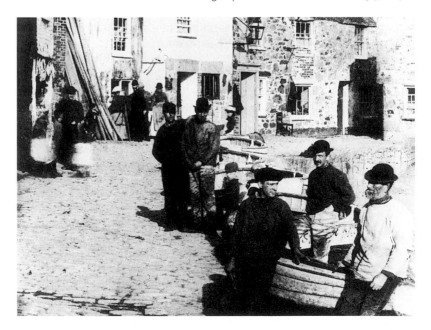

tangled with the law. A gale in the previous November had swept the cargo ship *Rosedale* onto Porthminster Beach, where it broke up.[44] Within days magistrates were fining those caught plundering the wreck, but the inefficiency of the official wreckers meant that it remained intact for several months. In January, Wallis was charged with receiving 'a quantity of brass eccentric bands' from two boys, James Stevens and Richard Taylor.[45] Wallis first denied having the brass but, having been followed to Penzance by the local policeman, Sergeant Jones, produced it from within a bag of bones. All three were found guilty. The boys, unable to pay their twenty-five shilling fines, were sent to Bodmin Gaol for a month. Wallis paid a £10 fine rather than suffer two months' imprisonment. The story both shows the risky legality of his work and, in the fact that he did not pay the boys' fine, may indicate a certain distance from the local community. Incidentally, the report of Wallis's cart being 'close by Denley's stores' in Penzance is the only independent suggestion of their business arrangement.[46]

Susan can hardly have been amused by the aspect of risk in the business. She is said to have been an ardent member of the Salvation Army in Penzance and St Ives, although no record of this has been found.[47] Alfred Wallis's certificate of enrolment – the Salvation Army Articles of War – has survived in St Ives Museum; it is signed and dated 4 March 1904, reflecting a late conversion. At services he played the melodeon, a portable organ which apparently sat across his knees;[48] the harmonium, also in the St Ives Museum, which is said to have been his is much larger than this and untouched by paint.

The closure of the Marine Stores is usually placed in 1912 and associated with the decline in the fishing industry in St Ives.[49] The great days of the local fleets appeared to be over but this may be coloured by the sort of nostalgia which was also central to Wallis's painting. As a measure of the decline, he told Albert Rowe that there had been 120 boats in the fleet when he was a boy (a period in which he had actually been in Devon).[50] The ways of the sea had remained relatively untouched until the arrival of larger steam boats in the late nineteenth century. There had always been a sense of community in the auxiliary activities: at least as many women were employed gutting and smoking fish on land as men involved in the catch. Seine fishing epitomised this cooperation, as shoals of pilchards were driven into the seine nets suspended vertically from a flotilla specially stationed on Porthminster Beach. Once the neck of seines was closed, the shoal was physically hauled alive from the sea while smaller boats ferried it to the shore. With considerable justification, visitors to St Ives saw this dramatic spectacle as an ancient communal ritual.

Such activities did not stop overnight but the catches diminished into unaccountable fluctuations. In some years scarcity drove the St Ives fleet to other waters, whilst in others there was an equally distressing glut.[51] Without fish half the community starved, with too many the market was flooded. Over a long period the decline was perceptible: in 1889 there were 164 pilchard seines, in 1921, the Council sought the removal of some Porthminster seine boats which had lain unused for nine years.[52] The smaller craft dwindled in number and, in the 1920s, large sailing boats were superseded by motor-boats, signalling a loss of the traditional skills associated with the sea.

This state of affairs may have been a contributing factor, but was surely not the main reason for Wallis's retirement. In 1912, Alfred was fifty-seven, but Susan was seventy-eight. Clearly he was vigorous enough to continue working, but probably Susan was not. They had accumulated enough savings four years

earlier to buy the little cottage to which they moved at 3 Back Road West.[53] Furthermore, they are said by Berlin to have been able to hire cars to take the family to Charles Wallis's funeral in Penzance; he died in January 1908.[54] In retirement, Susan received a pension, but Alfred had demands to pay the 'Poor Rate' towards the support of the poor, suggesting that he was still working.[55] He did odd jobs including moving furniture for Mr Armour the antique dealer in Fore Street. It may have been at this stage that he made and sold pink ice-cream to St Ives children. During the First World War, with the threat of German submarines, he helped to build houses for the military on the town's open headland, The Island.

Alfred and Susan Wallis lived together at 3 Back Road West for a decade. This period seems to have been settled, although he resented the support given to his step-children. When Susan died on 7 June 1922, they had been married for forty-six years. Left alone, Wallis's fierce determination and self-reliance began, very gradually, to turn into the suspicion and isolation which filled his last years. Just as he had fallen out with his brother over money, so he distanced himself from his step-children, believing that £40 in gold and £5 in silver had been taken by them at the time of Susan's death.[56] It is not inconceivable that she had already given it to Albert Ward to help his ailing bakery, but Alfred had a silent feud with Albert until the latter's death in 1928. That the resentment he felt towards the Wards was also eventually turned against Susan's memory may stem from his own suspicion of her generosity. Albert Rowe's description of Wallis's fiendish ranting at the memory of the 'black-hearted bitch' is, as Mullins commented, reminiscent of Edgar Allan Poe but perhaps indicative of the old man's most extreme moods.[57] Certainly, the missing money meant that he had to sell his cottage to Mr Spink, on 10 September 1924, with the proviso that he could remain there, for a minimal rent of one shilling per annum, for the rest of his life; the same arrangement was sold on to Mr Care in early 1942.[58] Wallis was, despite his resentments, invited to live with various members of the Ward family. Somewhat perversely, he accepted the offer of his nephew William Wallis, although he did not stay for long. The difficulty he found in living under another's roof, may have been heightened by sharing it with a new baby.

The story is that Wallis began to paint 'for company'. It was not entirely unexpected. His step-grandson Jacob Ward remembered him drawing during the period of the Marine Stores;[59] this may be considered a traditional seaman's hobby. By Berlin's estimation, he began to paint around 1925, buying brushes and household paint from a shop in the Digey, and visiting his friend Mr Edwards the next day with 'two or three paintings of boats'.[60] According to Nancy Ward 'several people had them from him, and he gave them to the children'; Thomas Lander added that if asked seriously 'he used to explain his work to anyone who really wanted to know'.[61] In this way, Wallis established a quiet local reputation. If he appeared obsessive − 'he had a passion for painting mackerel boats'[62] − it was accepted as eccentricity. Rowe particularly admired his fish although he believed he 'could paint better boats' himself.[63]

With time, Wallis only used household paints bought in small tins which are visible in photographs of his workspace. He had probably painted real boats with the paint and in its use Mullins has seen a literalness associated with a direct apprehension of his subjects. He usually painted on pieces of card left by various people including Mr Baughan the grocer. For a rag-and-bone man, this use of left-over delivery boxes was second nature. A new canvas might be bewildering. Indeed, all of the works on canvas which survive appear to have been

painted over compositions begun by others. It seems likely that both the composition and the texture triggered Wallis's response which, in some cases, incorporated the preceding work. Many of these paintings produced intriguing but sometimes alarming juxtapositions.

Wallis is often seen in the cloud of his late isolation, aggressive and maddened by voices: 'a man locked up darkly within himself' as Mullins wrote.[64] However, these conditions did not apply throughout his life, and may only have taken hold in his last five years or so. Undoubtedly his cottage fell into a state of decay towards the end, and he himself acknowledged that it needed 'a great repare' in 1938;[65] fleas were reported in 1941. However, a photograph of him painting at his table shows him fastidiously dressed in an apron, which also featured in eye-witness accounts (frontispiece). A number of figurines can be seen on a shelf and – in another curiously Poe touch – a stuffed magpie in a glass case. Nancy Ward recalled engravings of Queen Victoria and Lord Baden Powell, and some 'marvellous china'.[66] She remembered 'Peter walking over the sea' and there is a report of a *Last Supper*; presumably these were engravings after Raphael and Leonardo. The note of religious austerity was embodied in the 'enormous black Bible and an equally enormous, black Life of Christ' recalled by Ben Nicholson, but there were other books.[67] These essentially Victorian items speak for orthodox tastes.

It is said that Wallis did not go upstairs after Susan died.[68] Although various accounts – including Rowe's – show that this is mistaken, he lived, slept and painted in his single downstairs room. No wonder that he wrote that he needed 'more outing' rather than staying in painting. In the 1930s, the onset of his fears gathered pace. He suspected conspiracies. Undoubtedly his size and deafness made him a target for local boys. Mr Edwards told Berlin of Wallis hiding in his house from a Boy Scouts' rally; however, it has been suggested that he feared the uniformed scouts were invaders as boys had shouted down Back Road that the Germans had landed.[69] Eddie Murt has described boys 'tying two doors together and knocking both at once'.[70] For Wallis, such pranks soon became persecution. He met teasing with aggression, which became the norm; Frank Bottrell, who delivered bread, remembers 'you had to watch your back legs' to avoid being kicked out.[69]

Wallis had lapsed from the Salvation Army and his fears took on an increasingly religious tenor. He heard voices. These he elided into the female 'Douty Mighty', who scolded him. She tried to stop him painting, a prohibition he was only able to defy with support from Mr Armour. Berlin's psychological interpretation of these voices as those of Susan and of Wallis's oppression by 'duty' seems plausible.[72] At bad times he would be up all night fighting and arguing with these spirits, keeping the neighbours awake and emerging exhausted the next day. On other days, peculiar rituals could set his mind at rest: they included clearing the chimney – the principal channel for voices – of 'wires'. Such struggles were on an appropriately biblical scale for one who read the Bible every day, but they were also sporadic and cyclical, interspersed with periods of 'normality'.

As was the custom in St Ives with those unable to fend for themselves, Wallis was brought meals by well-meaning relatives and Mrs Peters his neighbour. The story of his ungracious treatment of this food – especially when brought by the Wards or the Rowes whom he suspected of poisoning him – is often recounted. That so many people claim to have supplied him, indicates that he was either overwhelmed with food or that the myth of Wallis is powerfully attractive.

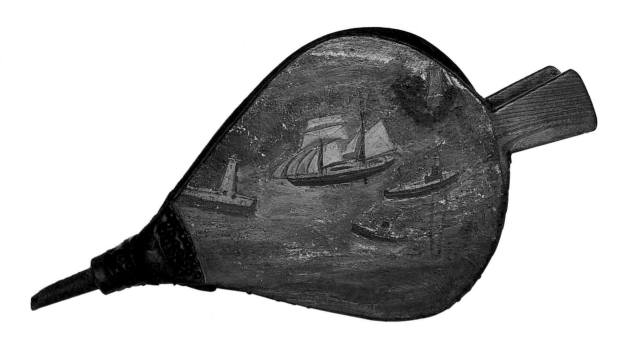

7
Painted Bellows
c.1933–7
Oil on leather
Private Collection

By 1928, Wallis was retired, widowed and producing paintings as a hobby. They were distributed to anyone who wanted them and his paintings on marmalade jars and other such items like the bellows (fig.7) may have been offered in (silent) exchange for the meals brought him. A few – Mr Baughan, Mr Edwards and Mr Armour (the grocer, watchmaker and antique dealer) – savoured the works, seeing in them qualities which went beyond their narrative or topographical detail. However, the interest paid by professional London painters, specifically Christopher Wood and Ben and Winifred Nicholson, transformed this local relationship. It bred scepticism and initiated the impression of some sort of conspiracy – either at Wallis's expense or with his connivance against a gullible art market. It cannot be doubted that this outside interest changed his life and, in effect, led to the further isolation of an isolated man. The local scepticism increased as outside interest grew, and his paranoia became more evident. That his desire to paint overrode these consequences is a measure of his compulsion and, later perhaps, the regular place of painting in his life. Hobby, compulsion, habit are the signs under which Wallis's work developed.

Little of this was conveyed to his London friends. His personal contacts were at first confined to Wood, the Nicholsons and one or two others, including the painters Colin Sealy and Alathea Garstin and the dealer Lucy Wertheim. He was also in correspondence with them, and with Ede, Barbara Hepworth and probably Herbert Read and Adrian Stokes, who were the first to write about his painting. Even when Wallis faced a major crisis, his London friends only received slight details. His paranoia seemed justified when he was apparently knocked down by a car in the Digey, an event datable to March 1937. Berlin asserted that it was the Mayor's car, but no accident is recorded in the local

newspaper.[73] It seems possible that Wallis was not actually knocked down, but that his deafness allowed a car to bear down on him expecting him to move. He was shaken 'inside and out'.[74]

For whatever reasons, the accident initiated the decline of Wallis's final five years. The solicitousness of friends kept him going through the bad periods which occurred with increasing frequency. Among his long-held fears, of which Berlin makes much, was that of ending his days in the authority's Workhouse, Madron Institution. The loss of his savings exacerbated this inevitable crisis. Nevertheless, probably as a result of the sale of his paintings, he managed to save £20 which he left with Mrs Peters to be set against his funeral expenses. If the Workhouse beckoned, a pauper's grave at least could be avoided.

The advent of the Second World War brought the unexpected return of Ben Nicholson with Barbara Hepworth, who evacuated to join Adrian Stokes and Margaret Mellis in neighbouring Carbis Bay. These four of Wallis's London ad-mirers renewed the interest in his painting, although he was no longer at the height of his powers and they were not frequent visitors. In 1940, on the Show Day on which local artists opened their studios to the public, Nicholson and Hepworth visited Wallis with the painter Peter Lanyon.[75]

A year later, in June 1941, Mrs Peters had to prepare Wallis for his removal to the Workhouse. He could no longer look after himself satisfactorily and one account suggests that he failed to observe the wartime blackout. He was also ill with bronchitis. In any case, Mrs Peters told Berlin of the resigned dignity with which Wallis prepared for this last journey over Penwith to Madron.[76] He lived in the Madron Institution for fourteen months. Nicholson claimed, in the account he wrote in 1943, that he settled in well, and that the staff and 'inmates' alike became admirers of his work which he resumed.[77] Both Stokes and Nicholson, and a number of others (Garstin and the writer George Manning-Sanders) visited. Some took him crayons and sketchbooks, unfamiliar materials which he used nevertheless (fig.51). Although the occupants slept in dormitories, there are unsubstantiated accounts of a 'cell' which Wallis painted with ships and which survived until the building was refurbished in the 1950s. Alfred Wallis died at Madron on 29 August 1942 at the age of eighty-seven. The money left with Mrs Peters and the efforts of Adrian Stokes and others secured a Salva-tion Army funeral on 3 September and a plot in Porthmeor Cemetery on the same hillside overlooking the Atlantic as 3 Back Road West.[78]

2
'So i must close'
Wallis's Letters

Alfred Wallis lay outside the strata of society in which 'art' was habitually given a value distinct from its constituent materials and labour. It seems likely that he regarded his own work as a hobby comparable to story telling or model making; indeed, he made model boats himself, giving one to Ben and Winifred Nicholson's son Jake in 1928 (fig.8). Such activities were specially valued, and certain contemporaries established local renown for their work. Thomas Paynter, who died aged seventy-six in 1941, was known for stories which were more comical than truthful, whilst Moll Barber carved boats and traditional figures, known locally as 'Joanies', from broken oars.[1] The making of such carvings may be perceived as echoing a tradition relating back to the ships dedicated in churches such as that at Zennor. The coincidence between Wallis's paintings and Barber's 'Joanies' lies in their making. Both were associated with the sea and made from salvaged materials. Both were activities in which some remnant of communal memory was made actual. That they were also sold was an additional benefit. Indeed, Wallis's letters reveal a commercial aspect to his painting which may be seen in the light of the economic changes in the town in the inter-war years from fishing to tourism, as well as personal requirements following the sale of his horse in 1924. His hobby could be a response to these changed circumstances. It may also be surmised that these circumstances allowed the 'professional' artists in St Ives to overlook him – although the gap between his work and their Impressionistic plein-air painting was considerable.

Even if ignored by these 'professionals', Wallis and his work had a place within the local community and this makes the nature of his encounter with Nicholson and Wood rather different. It has often been said that Wallis was 'discovered' by them in August 1928. This is a contentious term as it implies that he was in some way unaware that he was making art. What is understood is that their enthusiasm made Wallis's work known to the outside world or, more exactly, to that part of it concerned with art. As a result it is worth concentrating upon the relationships which emerged from this contact.

The survival of sixty-four letters from the painter's last fifteen years helps to establish a view of his life as he sought to report it. The forty-eight letters to Jim Ede, then an assistant curator at the Tate Gallery in London, have long been known, and extracts have been published to give a flavour of the painter's language and ideas. Only relatively recently have a further thirteen letters which were sent to Nicholson resurfaced. By happy chance, together these two groups cover the years 1928–39 and can be augmented by other accounts. They cover the period of Wallis's greatest activity as a painter. Although some are very brief, others veer between pithy distillations of ideas and worrying about matters in hand. In essence, they are the letters of an old man, aware that

8
Winifred and Andrew
Nicholson in c.1932
with Wallis's model
boat
Tate Gallery Archive

he is writing to more educated people and conscious of weighing his words. Nevertheless, a careful reading provides an impression of Wallis's life and production which is different from that usually sketched out. They suggest the constituent elements of his art and its acceptance by his correspondents. One factor is fundamental to their understanding: he had met Nicholson but never met Ede, and the resulting tone is quite distinct. As those to Ede have been public for so long their distant and, at times, deferential tone has coloured our view. The letters to Nicholson are notably warmer and suggestive of a special relationship.

Ben Nicholson's retrospective salute is sharp in its reconstruction of the August day in 1928 when he and Wood met Wallis. They came up from Porthmeor Beach, and:

passed an open door in Back Road West and through it saw some paintings of ships and houses on odd pieces of paper and cardboard nailed up all over the wall, with particularly large nails through the smallest ones. We knocked on the door and inside found Wallis, and the paintings we got from him then were the first he made.[2]

Schooner and Lighthouse (fig.9) was one of these paintings and, by this account, probably dates from 1925–8. On slightly battered card with the requisite pinhole, the urgency of Wallis's work is laid out. A fully rigged schooner is worked into the heavy paint surface just as it is envisaged as struggling in the rough sea. The components are recognisable as signs rather than attempts at illusion; sea and ship, land and lighthouse stand in the natural relationship of memory rather than the conventions of perspective. They are drawn with a nervous exactitude which would relax in later works. Nicholson recognised in these qualities Wallis's individual vision.

The account of this first visit is corroborated by other correspondence. The Nicholsons – Ben, Winifred and baby Jake – were holidaying at Feock on the south coast, with Wood, Marcus and Irene Brumwell, and the doctor and painter John Wells. However, Ben Nicholson's asthma was exacerbated and the trip to

St Ives (where Wood had painted in 1926) was prompted by the search for better conditions. They were aware of the town's reputation as an artists' colony. Even though it is unlikely that they admired the Academicians who had studios there, the journey may have been timed to coincide with the St Ives Society of Artists exhibition. This opened on 6 August at the Porthmeor Gallery and was reviewed in the *Western Morning News*. As Nicholson recalled, the Gallery was near Wallis's house, and this may explain how they happened upon him.

By early September, Wood had been to St Ives to look for rooms.[3] The party's transfer was made shortly after: the Nicholsons took a house near the quay and Wood took Meadow Cottage overlooking Porthmeor Beach not far from 3 Back Road West. To Wallis they must have appeared to be a strange company. The Nicholsons, Christian Scientists and vegetarians, were earnest and concentrated in their work. Wood, a charming opium addict and bisexual, had recently fallen in love with a married Russian woman, Frosca Munster, who soon joined him. Wallis seems to have accepted them all at face value. The Nicholsons bought paintings before their return to London in mid October; Munster was asked to take others.[4] Wood, who remained in St Ives into November, provided crucial insights through his letters. 'He seemed pleased with the photos,' he wrote of Wallis on 28 October, 'and the book of Roo-so but said "At any rate he knew nothing about boats"'.[5] This shows that the Londoners not only compared Wallis to the Douanier Rousseau, the untrained Parisian painter, but reinforced that perception by introducing him to the Frenchman's work (fig.57). He served both as example and encouragement, even if Wallis offered a specialist's rebuff. This was not their only yardstick, as Wood remarked of the paintings: 'I am not surprised that no one likes Wallis, no one liked Van Gogh for a long time did they? I see him each day for a second, he's bright and cheery'.[6]

About a week earlier Nicholson sent Jim Ede photographs of paintings done on holiday. They included one by Wallis, over which he was enthusiastic: 'It is enchanting – has all the feeling of a sea port & what is more looks like a ship. I'd love to see some and will surely want to have some if he wishes to sell them to procure tobacco'.[7] From St Ives, Wood enquired:

9
*Schooner and
Lighthouse* c.1925–8
Oil on card
16.5 × 30.5 cm
Private Collection

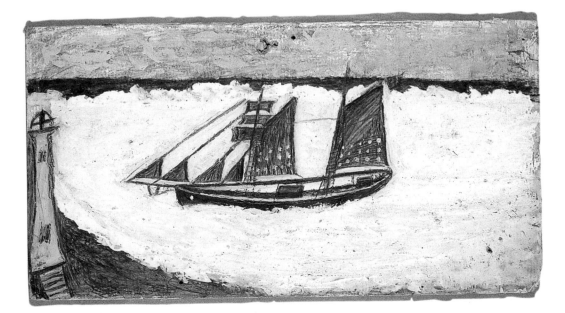

What did Jim think of Admiral Wallis – I often see him – took him some baccy & a few papers last evening, he showed me those lovely boats Ben sent him. I think he appreciated them as he had noticed much the same construction as in his own pictures. He said when he came to my house that "they looked as well as anything draw 'em off".[8]

On 17 November, Wallis himself wrote to his 'Dear friends' the Nicholsons explaining 'i got a few mor picturs don and i receved your potoes'.[9] These photographs ('potoes') were probably the 'lovely boats'.

Three days later, Wallis sent paintings to Nicholson accompanied by a warm letter.[10] It exemplifies his idiosyncratic spelling and syntax (fig.10):

> November 20
> 1928
> Dear Sir i Receved
> your oder [order] and i have sent
> on som more and i hope
> They will please
> i shall have To stop and
> have a bit of outing for i am
> getin of my food By Being
> in Two much
> so i Think what i have
> sent on will please
> They That you sent Back
> Rund [round] Befor They was pay
> ~~They~~ The one with Ruf
> sea is st Ives Bay with
> fishing LuBoat [lugboat] Drove
> a shore over By Hayle
> Bar
> a Steam Drifter
> so i hope you will get Them
> all right so i must Close for The
> Time hope you are all well
> from your Truly friend
> a Wallis respects To all

10
Wallis's letter to Ben Nicholson, 20 November 1928
Tate Gallery Archive

Here is the earliest of the artist's own descriptions of his subjects. It is a ship but one that had foundered; a drama, which he explains in case the painting itself does not convey it. By pinpointing Hayle Bar in the estuary to the east of St Ives, the event is actualised. It was not an uncommon local occurrence: the schooner *Hilda* had run aground there earlier in the year.[11] Unfortunately it is not easy to link the description to a particular painting. The opening of the letter indicates that Nicholson was submitting orders for works to Wallis. The distribution of these paintings was obviously underway quickly, as Ede borrowed one before Christmas.[12] The painter was sent cheques (which were cashed by Mr Armour and Mr Baughan), but he may also have been sent postal orders – an alternative explanation of the 'oder'. In any case, Wallis and Nicholson already had some sort of commercial understanding.

Towards the end of November 1928, Nicholson sent another book, as Wallis's letter of the 23rd indicates:[13]

i Think i will send on
what i have witch is
a Bit different
i have your Book
which i Thank you
Came in while i was Ritin
Their is Nothin on The water
Than Beats a full Riged ship

Nicholson is known to have given him F.W. Wallace's *In the Wake of the Wind Ships*; the final comment suggests that this was the moment. Mullins has recorded seeing the volume which was well thumbed.[14] Like the book on Rousseau, this gift cast doubt over Wallis's crossing to North America. Mullins pre-empted this question by drawing attention to the work inscribed 'Bellaventur of Brixham Larbordoor Newfoundland Ice Burges' and it is now known that this was the ship on which Wallis served in 1876. Nevertheless, it seems likely that Wallis did use the illustrations in the book as the basis for some paintings. In particular, the large *Three-Masted Schooner near a Lighthouse* (fig.21) bears a resemblance to a photograph of the *Shannon* under construction.[15] The book provided him with a reminder of once familiar details.

The book probably struck Nicholson as coinciding with the maritime experiences of which he must have been told. However, it may also be seen as directing Wallis's choice of subject matter. It seems like an infringement of the 'primitive' isolation in which he was supposed to have worked, encouraging one particular tendency. The truth probably lay somewhere in between: Nicholson must have been aware of the potential influence but gave it in friendship; Wallis was refreshed by the book and adapted some images which struck a chord with his own experience. In return he soon insisted that two works be accepted as a gift;[16] the link is implicit.

Ede had already become more closely involved. He and Winifred Nicholson recommended that a certain Miss Bromby take an interest in the painter. Her account, as reported by Ede to Nicholson, is a valuable portrait of Wallis, albeit through the eyes of a stranger:

he's evidently turned over a new leaf as she's found no fleas – she finds him a dear quiet dignified person with the most unmercenary mind she's ever met. She's got lots of cardboard 'cos he said he had no more. He speaks of you as 'HE' although you had never been previously mentioned 'he has most of them'!!! He says he will have to do less as it was only a hobby & he now sits in too much – what with all these 'orders' – his life he says is out of doors

so you must not overwork him, poor thing. He says he's going off his food with overwork!!!
She asked him what he used, '*Peacocks*' he replied as though you couldn't expect an artist
to use any other. I suppose 'Peacocks' is the local 'grocers'. He was boiling 'his charge' when
she went – 'I can see him now with his pale little face, thin nose & upright figure' – 'I can only
do ship' he said looking at the repro of the Last Supper on his wall 'I would have taken off
that long ago – I say I would have taken off that long ago if I could have but I *can't*. I can only
do ships. He was a man of Principle that is what I admire about Christ – He was a man of
Principle – what would the world have been without him! The world's in a bad enough state
but what would the world have been without him!'
Your next batch are all grey – he's feeling grey it seems. [17]

Along with the tone of friendly amusement, this account shows Wallis as 'digni-
fied' and trusting. The demand that he felt as a result of his London connec-
tions is repeated; as he is also 'unmercenary', the suggestion of some
commercial deal remains. Finally, the reported speech about Christ is indicative
of his strong religious and moral view of contemporary events. Although he
probably wanted to 'take off' the Leonardo because of its religious significance,
it would require a mastery of a multi-figure composition which he did not
believe within his capabilities. Nevertheless, he attempted one or two compara-
ble if unidentified narratives. One shows figures gathered by a boat, another a
crucifixion (fig.11) with an unresolved figure below, which is troubling because
of the religious compulsion and struggle that it suggests.

In January 1929, Wallis wrote an especially friendly letter to Nicholson urging
that 'the little' – Jake – should sail the boat which the painter had made for him.
He also made an extraordinary observation about his own painting style, re-
marking without malice: 'i serpose you hav a good fon over my pictures
Because i never learnt and meerly out The head'. [18]

The only letter from Nicholson which is recorded was written in the following
month. It shows him selecting works, including 'one with the land like clouds
behind a ship with white sails, blue sky, yellow sun'. [19] Four were returned and
nine retained; the latter were priced in shillings according to an evidently pre-
determined scale, 'one 3/-, two 2/-, six 1/-'. Although Nicholson refunded the
postage for the parcel (sending 14s. 6d in total), the values linked to the size of
card appear very modest. Nicholson seems to have established the scale
because Wallis had no conception of the prices he should demand. From his
point of view, Wallis may have felt quite satisfied; that year the price paid to
pilchard fishermen fell from 25 shillings to 15 shillings per thousand caught. [20]

Wallis's first surviving letter to Ede dates from 24 April 1929. [21] Replying to an
enquiry about his technique of leaving the card visible, the painter declared: 'i
Thought it not nessery To paint it all around so i never Don it'. This was a matter
of judgment over which Wallis felt no anxiety. It may relate – as Mullins
implies, [22] – to *The Blue Ship, Mount's Bay* (fig.18), a painting which Ede owned
and which is notable for the unpainted card between the sails and rigging. The
orange card, significantly imitated in the orange paint of the deck, is height-
ened by the surrounding blue sea, which establishes a balance of complemen-
tary colours.

Wallis also discussed painting on boxes. These were surfaces favoured by
Nicholson in the following years, perhaps as a result of Wallis's example. It is
significant that the painter wrote of one sent specially:

11
Crucifixion or *Allegory
with Three Figures
and Two Dogs*
c.1932–4
Oil on card
25.4 × 17 cm
Kettle's Yard, University of
Cambridge

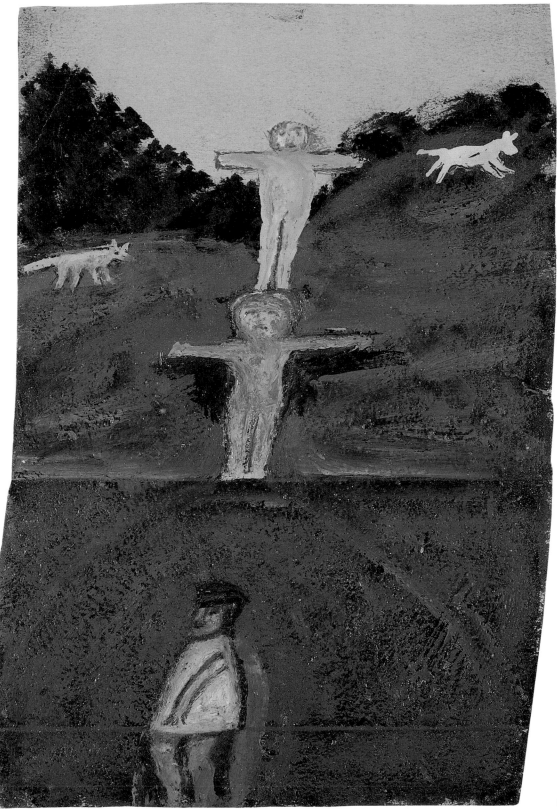

i have put on The front
what i Could it is diffelt [difficult]
To put any Thing on
and i have shaped out
a Boat one End and a vessel
an The other my paint
is Don and gon Thick
so The one on Each End
you Can do your self
i Do not Think i shall
Trouble aBout Buying
much mor pant i have
used many pounds of pant [23]

It is symptomatic that he was happy with Nicholson, a fellow artist, colouring the sketched-out design. His reservations about painting were troubling; he stated, 'i Do not want Coming in and out i do not giting living at it', and suggested that he still gave works away: 'i am not paid for Thin i do put aBout'. However, in anticipating painting less, he also allowed for the possibility that: 'as i see any Thing i fancy i should like to take off if i saw any passin on The water and i had a tidey spy glass Then i may Be aBle'. This exposes his compulsion. Even when proposing to give up, he foresaw still wanting to make one or two. The mention of a spy glass – although we do not know if he ever got one – confirms that he responded to subjects around him.

Within a year of meeting him, the Londoners were distributing and publicising Wallis's paintings more widely. It was Ede's habit to hang paintings by his friends in his office at the otherwise conservative Tate Gallery; a Wallis ('boat with big grey sail') appeared alongside works by the Nicholsons.[24] With Wood, they were leading members of the avant-garde 7 & 5 Society; in 1929, Winifred chaired the Society, and Ben and Wood were on the hanging committee. They included two paintings by Wallis – listed as *Mount's Bay* and *Lugger* – in the March 1929 exhibition; tellingly these were priced at four and seven guineas respectively, whilst his sponsors' works ranged between fifteen and fifty guineas.[25] Ben Nicholson selected one for the collector Helen Sutherland.[26] Given the 'faux-naive' style of Wood and the Nicholsons – whose paintings of St Ives (figs.53–5) dominated the show, the presence of Wallis's works was an affirmation of the immediacy of feeling and a guarantee of authenticity. For hostile critics, even praise of Wallis's paintings could be barbed. Calling them the works 'of a genuine illiterate … well into his second childhood', one critic remarked: 'they afford too refreshing a contrast with the would-be unalphabetic attempts of some of the group'.[27]

There is no indication that Wallis was consulted over the exhibition, but the sequence of letters is fragmentary at that moment. A much longer break occurs in 1930–32. This was a chaotic period for the Londoners. Wood committed suicide under the influence of opium (or lack of it) on 21 August 1930; Ede and the Nicholsons were involved in putting his things in order. Ede published a biography of the sculptor Henri Gaudier-Brzeska (1930, reissued in 1931 as *Savage Messiah*) and was suffering periods of illness which were not resolved until an extended stay in Tangier in 1933. The Nicholsons were experiencing marital difficulties and, in 1931, Ben began to divide his life between Winifred Nicholson and Barbara Hepworth. It is known that he, Winifred and Jake revisited Wallis on 9 September 1932, on a day trip from their family holiday at Par.[28] Wallis must have seemed far away and, perhaps, unlikely to approve. Further-

more, Nicholson and Hepworth were increasingly committed to abstraction for which the 'objectness' of Wallis's cards may have served as an encouragement but were otherwise indicative of different concerns.

Wallis continued to work, probably in the same sporadic way. The contacts in London had broadened. Wood's dealer, Lucy Carrington Wertheim, had apparently visited him during 1930 with Sophie Thomson and noted that he favoured Quaker Oats boxes. Recalling that he was 'so completely unmercenary that I believe he would have been satisfied with a tenth of the sum I gave him', Wertheim showed twenty of his works in her gallery in early 1931.[29] By this route, and the single showing with the 7 & 5 Society, his paintings briefly contributed to the most advanced circles in British art. This could have been a passing fashion but for the strength of the constantly renewed work and the importance of its Hampstead-based supporters. Hepworth was an enthusiast; as was Herbert Read, the most stalwart champion of modernism in London. As part of that process he published the important survey *Art Now* in 1933, in which Wallis's *Cornish Port* (fig.26) was illustrated. Nicholson certainly prompted its inclusion; it is not clear whether this was out of support or because of a perception of what the painter represented for contemporary artists.

Wallis's letter to Nicholson in mid 1933 further reinforced the image of a business relationship. He had alternatives to boats: 'i Thought it would Be a Chainge as i have got ships of all kinds here now'.[30] Then he discussed his artist buyers and potential sales:

i do not
shaw Them for sale Those
That have had from me is
Thous That Can Draw Them
selves This is no place To
sell it is all Right to make
But not To sell inlan Towns
is The Best for sellin ships

This shows his shrewd assessment of the commercial potential. In the following spring, he wrote of works that 'would suit you and Mr Ede for may and summer season', and would wish Nicholson 'a fin sumer of Bisaness'.[31] Certainly both Londoners were distributing the paintings, whether by gift or resale, and Wallis was under no illusions about this. Perhaps he saw them as his agents – hence his strenuous assertions that very few others had his work. Knowing something of the St Ives Society of Artists, he may even have believed that the Tate Gallery was commercial and Ede a dealer. Such an interpretation may also be suggested by the discussion of paintings returned to Wallis. The practice arose as a result of their geographical separation, but for the artist it was a means of gathering the opinions of others. Some were adjusted as a result, as he would tell Ede of a returned batch two years later: 'i do not open Them ontill i want To alter Them'.[32] It seems likely that altered works found their way back to London.

The letters to Ede, which become regular in 1934, show Wallis's concern to explain his work to someone he had never met. Five times between 1934 and 1936, he told him: 'i do most what used To Be what we shall never see no more avery Thing is altered'.[33] The work was thus justified by its presentation and recording of a lost past. He had not used this argument with Nicholson, indeed the 'spy glass' specifically indicated that he was looking at passing shipping. Perhaps Wallis anticipated Ede's expectations, understanding his interest to lie

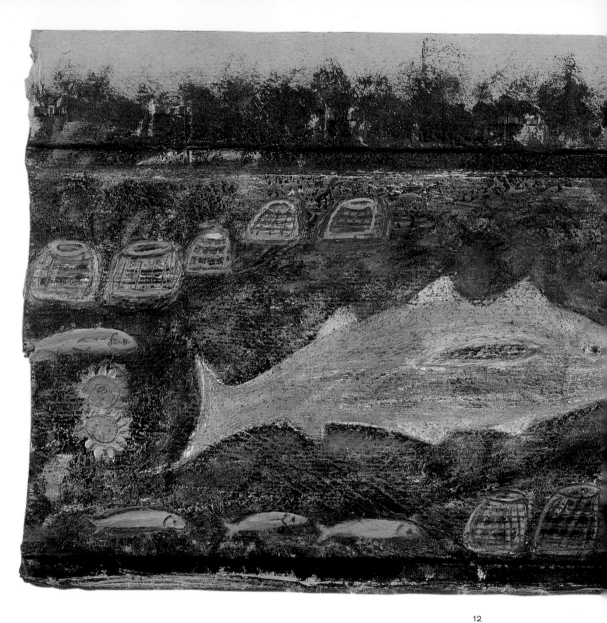

12
Fishes and Lobster Pots c.1936
Oil on card
22 × 46 cm
Kettle's Yard, University of Cambridge

in a nostalgia for the past often associated with St Ives tourist items; he may even have been told – as was Nicholson – that Ede had visited St Ives as a student at Newlyn before the First World War. Whatever the case, the past became a more frequent subject and explanation: 'The one with The Boats and harbour The Saynes shut is what used To Be'.[34]

Many of Wallis's letters to Ede are quite mundane and businesslike. Works were regularly too large to go by post and the most frequent exhortation was 'i should lik for you To Com and serlect for your self any Tim'.[35] Ede never went, as ill health brought his retirement to Tangier in 1936.

There are also insights. Although the disappearance of his savings lay at the bottom of his suspicion of the Wards, Wallis felt that he had what he needed. In 1935 he announced:

i Thought i would
give The Doctors home
That lot of pictures
out of Charity and you
Bein in london you
would know Best Wher
To Drop it to [36]

In the Depression of the early 1930s, the need for such charity was not hard to find. He seems to have had Dr Barnardo's in mind, as elsewhere he explained that he had seen a picture of a boy in the paper:

i Thought if he had The worth givem it would
Be all help i ham poor my
self a penchener of Old age
the paintins do Com in To
By Clothin or any thing in
that way needfull [37]

To this he added that money 'augt To Be put That way mor Than it is not in simenes and theaters sunday'. Here his Cornish chapel disapproval of Sunday activities – of which cinemas ('simenes') were a favourite target – emerged. It was to this stage, furthermore, that Nicholson dated a letter, which has only survived as a fragment, including the ominous claim: 'i Tell you what i am a BiBle keeper it is Red 3 hundreds sixty Times a year By me and That is avery ons Duity'.[38]

In 1935 Wallis was eighty, and began to link a declaration of his age (some-times miscalculated) to a description of his work. He added some general remarks to Ede about painting which reflected the process of trial and error by which he worked:

i do not To put Collers what
Do Not belong i Think i spoils
The picturs Their have Been
a lot of paintins spoiled By
putin Collers where They do
not Blong good work it want
pay To ad Colleers it spoiles
Ther work[39]

This speaks of experience – the spoilt pictures must be his – and judgement. Not long after, any models in reality were discounted: 'all i do is hout of mery i do not go out any where To Draw'.[40] In case this suggested the isolation of the studio, he assured Ede as late as November 1936:

i am self Taught so you
cannot me like Thouse
That have Been Taught
Both in school and paint
i have had To learn my
self i never go out to paint [41]

In this statement there is an understandable combination of humility about his work and pride in its achievement.

Into this run of letters, which suggest a man finding fulfilment in a difficult hobby, other anxieties erupt. In March 1937, he confided:

you mentined aBout my Ellenes [illness]
i was verry porley and i was not
out for 3 days and i was knocked
Down with a moter Car Coming Behind me
and it have shook me insid and out
i Cannot stand That knockin about
i wonder i was not killed [42]

Poignantly, the accident is reflected in the shaky handwriting, from which confidence seems drained. Although he recovered somewhat, it was a watershed beyond which the pent-up forces within him were unleashed. At home he had already given way to paranoia – about spirits and little boys alike, now this spilled into his letters. When he wrote of people envious of his painting, in July 1938, his paranoias seemed confirmed:

i am Thinkin of
givin up the paints
all To gether i have nothin
But Percuitin [persecution] and
gelecy [jealousy] and if you can
Com Down for a hour or 2
you Can Take Them with
you and give what They
are worf To you afterwards
These Drawers and shopes
are all gelles of me[43]

Repeating that he was persecuted, he concluded 'i want To live To The Schpter [scripture] not mallace'. In fact, exaggeration seems more likely than delusion. It is not wholly inconceivable that his painting was a source of jealousy for other artists ('Drawers'), as he was singled out for praise in two important texts on modernism. At the beginning of 1938, his *Houses with Animals* (fig.13) opened Read's article on English painting in the prestigious Parisian periodical *Cahiers d'Art*.[44] Whilst its readership may have been limited in St Ives, the artists there were likely to have read the passage on Wallis in Adrian Stokes's influential *Colour and Form*, published the year before. These flattering assessments may well have led to sniping from professional artists who had previously paid Wallis no attention and whose conception of subjects he favoured was summarised in Borlase Smart's *The Technique of Seascape Painting* (1934). Although Stokes and Margaret Mellis had recently moved to Carbis Bay and visited Wallis, it is likely that he was more sensitive to assault than aware of praise.

Whatever the case, the painter's requests that Ede come or send for his paintings became more earnest. Three days after writing of 'Percuitin and gelecy', he said that he had thirty or forty works:

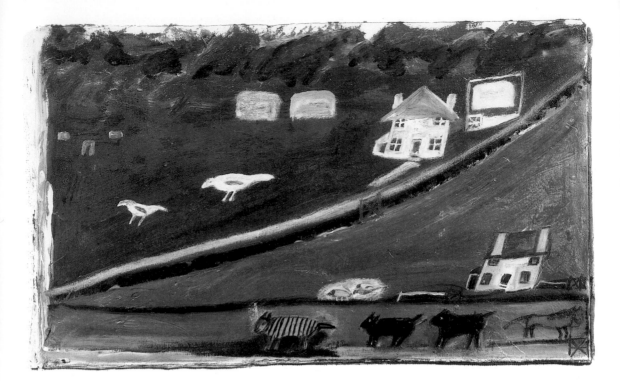

i want Them
cleared out i do not
know how soon i shall
have To moove The house
wants a great Repare
i think Their They are so
good if not Better i have
don [45]

13
Houses with Animals
*c.*1936
Oil on card
30.5 × 50.8 cm
Courtesy Crane Calman
Gallery, London

A fortnight later, he wanted none sent back.[46] He really seemed intent on stopping.

It is not clear what precipitated this crisis nor how it was resolved, although the interest of Stokes and Mellis may have placated him. The next letter to Ede, which is also the last, came on the eve of war in July 1939. Wallis confessed to having 'som Days farly well and som not much'. Of his work he said that he had done 'verry little latly only one or two now and Then gave up all Togethe very near'.[47] Perhaps in view of Ede remaining abroad, he also wrote:

sence The War
Every Thing Seems To Be
in a on settled stated
natain against natain
it seems all over The
World Schrisper The Big
War is The Comencent of
Trouble Their as Been
nothin Ever sence
i serpose it is Just The
sam with you i hop it
will soon com To a proper
settled peace

In this state of affairs, little news of Wallis reached the outside world. Stokes and Mellis, Nicholson and Hepworth, Gabo and Lanyon provided him with a late flow of what Stokes would call 'admirers of which at that time there were many'.[48] Among them was Mellis's friend Wilhelmina Barns-Graham, a painter and neighbour of Wallis from 1940, whose recollection of his house may stand for many others:

It seemed grey and dirty, paintings everywhere, even the tabletop was a painting. Piles against the walls and in the doorway on the right-hand side panel were paintings one after another ... with no interval between them from ceiling to floor, greys, blacks and greens on cream-painted panels.[49]

The profusion of these works confirms Wallis's continued productivity, and tends to support Stokes's view that his decline 'must have developed very rapidly' towards the end.[50] In 1942, Nicholson wrote to Ede in America about the painter's situation in the Madron Institution:

in the end he settled in v. well & ... his paintings were admired greatly ... But he has had to go to bed about 3 weeks ago & I went over shortly after & he seemed to me through with this life. Up till quite a short time ago he'd been drawing & painting but he seems so old now that there is not much of him left. He asked after you once or twice sometime ago & I said you were in America which seemed to comfort him as otherwise I think he thought you had forgotten him or his work. No, I don't think a good Wallis is representational, it is simply REAL?[51]

Nicholson's assessment of the painter's condition was uncannily accurate: the letter was written on the day that Wallis died.

3
The Wreck of the Alba
Wallis's Paintings

Early in his activity as an artist Wallis settled on the combination of pencil and household oil paint on card. The paints were readily available locally in limited colours, usually black and white, blue and green, some yellow and a little red. By mixing them during application, he conjured up the peculiar atmosphere of his work. The paint was generally only deployed after the subject had been sketched in pencil often in considerable detail. Evidence for this careful preparation is especially clear in the partial crayon and pencil drawing of ships which is inscribed 'FISHING LUG[GER] ENDEAVOU[R] St IVES CORN[WALL]' (fig.14). The linear details were laid out and pencil was often used again after painting, sometimes cutting into the rubbery surface of the drying paint, in order to restore the finer points.

The cardboard cost nothing, as Wallis used scrapped boxes which varied widely in their qualities and effects. The thick dense card of packing boxes could absorb the paint quickly, resulting in the matt effect found in *Fishes and Lobster Pots* (fig.12); other substantial cardboards could carry a considerable weight of paint and allow the glossy finish of works such as *Two Boats Moving Past a Big House* (fig.32). Strawboards, usually of a medium thickness, could hold the paint but also provided a strong orange or ochre base colour to be accommodated within the composition – as with *St Ives* (fig.22). The whitest and most lightweight cards came from packets (from cereal to underwear), and the painter often used the white as a more neutral ground than the strawboards. Whilst the glazed finish to the card was less suitable for thick paintwork, it did allow the movement of thin veils of paint, exemplified in *Sailing Ship and Orchard* (fig.38). Wooden panels were used more rarely. Although less absorbent they could carry heavy paint-work and, as in the case of *The Wreck of the Alba* (fig.47), allowed the inclusion of tobacco and other materials to add texture. There are other possibilities, but even these establish that the range of potential effects arising out of the handling of such humble materials was considerable and that Wallis explored them to the full.

The shape of the card was also a contributory factor. As Ben Nicholson explained in 1943:

> he would cut out the top and bottom of an old cardboard box, and sometimes the four sides, into irregular shapes, using each shape as the key to the movement in a painting, and using the colour and texture of the board as the key to its colour and texture.[1]

By this account, and it is borne out by close inspection, the apparently rough forms of the cards were deliberately imposed by the artist. Further evidence for this is found in Wallis's judicious rejection of a box sent by Ede: 'The out side one is not worf Trouble it was Broke one End was [bro]ken in Too'.[2] Thus he did not simply paint on scrap, but actively modified his cards for his own purposes.

14
'Fishing Lugger Endeavour, St Ives – Cornwall' c.1938
Crayon and pencil on card
25.7 × 33.7 cm
Kettle's Yard, University of Cambridge

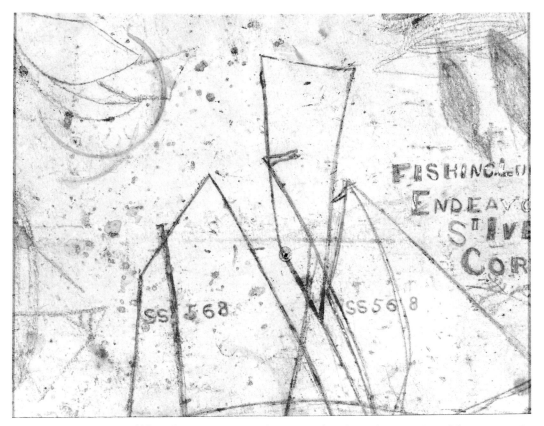

Although many paintings have straight edges, the trimming of the corners, in particular, appears to have been a process of familiarisation.

If his technique evolved with experimentation and experience, it did not take Wallis long to know his strengths. His initial response was to locate a ship broad-side at the centre and to gather the rest of the composition around it. This was a means for display both of the necessary maritime details to the viewer and of the painter's ability to evoke the surrounding atmosphere. If a ship was to be shown changing direction, he preferred to rotate the composition as a whole – as exemplified by those in dock in *White Sailing Ship* (fig.2). Although this ignored conventions of perspective, Wallis did conceive his own pictorial illusions. His vessels sit in the water with complete conviction, and the modulation of the water-line conveys the urgency or difficulty of their progress. Wallis appears less concerned with making these ships real for the observer (even if this occurs) than with conveying his own experience. His style maintains his own presence and asserts the validity of his own vision and memory. They are narratives of sorts, in which the storyteller is perhaps rather carried away; it was Wallis's gift that he found the means to carry his audience with him.

An attempt to establish a chronological sequence for at least some of the paintings may begin with an expected progression from simplicity to complexity. This has the fault of a generalisation but serves as a point of departure. Ben Nicholson said that *Schooner and Lighthouse* (fig.9) was one of the paintings that he bought from Wallis in August 1928 and that it was among 'the first he made'.[3] This suggests that it dates from 1925–8 and, as such, is one of the earliest reliable witnesses. The technique is fairly rough, with the paint heavily

worked into a creamy surface. Blue is preferred to black as the mixer for white, and, apart from the central schooner, other elements are pressed to the sides of a fairly regular card. The concentration on detail is invested in the ship. Remarkably similar evidence may be offered to date *Two-Masted Brigantine* (fig.15). The painter Doris Vaughan indicated that her painter husband Colin Sealy, who moved to St Ives in 1927, bought it from Wallis in the following year. She added 'Kit Wood and Ben Nicholson discovered him a few days before my husband so that he [Wallis] had not got many left'.[4] The style is certainly closely comparable to *Schooner and Lighthouse*, and has the added evidence of being painted on the reverse of a timetable for cheap rail fares between 9 July and 23 September 1928.

These two works may, therefore, be used as yardsticks for Wallis's painting in 1928. It is possible to cluster around them other paintings, among which are *Sailing Ship with Lighthouse*, which belonged to Nicholson,[5] and *Two-Masted Ship in Full Sail near a Lighthouse*, which belonged to Ede (fig.16). Both show schooners, similarly drawn in skeletal style, with a small lighthouse squeezed on an island to the side. Some variety is explored in the sea: in both paintings owned by Nicholson it was achieved by heavy impasto – as if the paint literally acted for the water – in the last, calm is suggested by long striations. In each this is achieved by dragging one colour over the other, in horizontal strokes. These characteristics and the dominance of blue are also found in slightly more elaborate paintings of schooners and two-sailed luggers, such as *Seven Boats Entering Harbour* where the wider setting enforced a reduction of details for the ships.[6] This, and the limited colours, also form links to panoramas of schooners crossing Mount's Bay, especially *Mount's Bay and Five Ships* (fig.17). The location is recognisable from Wallis's abbreviated cone for St Michael's Mount itself and the outcrop of rock guarding the entrance to Mousehole near the opposite extremes of the bay. They locate the boats as putting in to Penzance or Newlyn, which shows Wallis looking back to his experience at sea during the early 1870s.

15
Two-Masted Brigantine c.1925–8
Oil on card
30.2 × 59.1 cm
Tate Gallery

16
Two-Masted Ship in Full Sail near a Lighthouse c.1925–8
Oil on card
24 × 51 cm
Kettle's Yard, University of Cambridge

These paintings secure what may be recognised as the style of Wallis's earliest period. The relative simplicity of the compositions, the limited palette and the roughly dragged application of the paint establish a general homogeneity appreciable in other works. It is apparent, for instance, in *The Blue Ship* (fig.18), even though Ede dated it to circa 1934 'at a v. rough guess'.[7] This work combines the concentration on a single schooner with the addition of an encircling geography made explicit through the inclusion of St Michael's Mount. Again the colour is limited and the paint layers dragged over one another. However, the whole is enlivened by the contrast of the blue with the orange strawboard which may have become more extreme with age. If he had filled this in, he would have had to work around the rigging and to duplicate the bold texture of the sea within these confines. He did this in other cases – simply re-drawing in pencil over the paint – but here he desisted. The explanation, which may relate to this painting, was 'i Thought it not nessery To paint it all around'.[8] The painter gave most of his thought to the schooner; the hull is the same ultramarine as the sea which is worked in horizontal stabs with white overlaid. It seems that Wallis only turned his attention to the upper half when these areas were resolved. The change is visible in the paler sea above the line of the hull. The sense of urgent brushwork may, quite prosaically, be to do with Wallis's technique of mixing the colours on application, but it helps to suggest the speed of the boats for which he was re-enacting a swift efficiency.

17
*Mount's Bay and Five
Ships* c.1928
Oil on card
44 × 55.5 cm
Kettle's Yard, University of
Cambridge

18
The Blue Ship c.1928
Oil on card
43.8 × 55.9 cm
Tate Gallery

19 *Right
Seascape* c.1928
Oil on canvas
60.8 × 73.6 cm
Kettle's Yard, University of
Cambridge

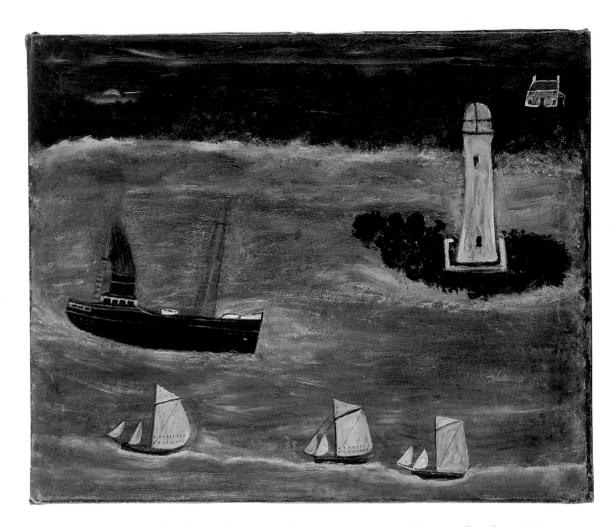

Another work, somewhat innocuously known as *Seascape* (fig.19), probably belongs to the last quarter of 1928 when Wood was in St Ives. As he was its first owner, it must predate his death in August 1930. Unusually, it is painted on canvas and this may have been supplied by Wood. The painting may be tentatively linked to Ede's enthusiastic 'what a glorious Wallis Kit's is of the 5 [sic] ships yellow on a grey ground'.[9] It shows something of the ambition indicated in Wallis's description of the untraced painting of 'St. Ives bay with fishing LuBoat Drove a shore over By Hayle Bar'.[10] The subject of the canvas is typical: a steamer passing between three sailing ships and an island lighthouse recognisable as Godrevy in St Ives Bay. Behind, a steep shore dips to allow a view of the crescent moon. The charcoal grey sea may be determined by Wallis's need to cover a canvas begun by another artist. Significantly, his composition responds to the only unevenness of the canvas: a margin caused by working up against the stretcher. All the major details are attached to this two inch margin: the landscape rises to it, the steamer departs from it, the sailing ships bob about it.

It is possible that one of Wallis's most ambitious double-sided paintings also dates from this moment: this is *Saltash* with the *Three-Masted Schooner near a Lighthouse* on the reverse (figs.20, 21). Nicholson described *Saltash* as 'rather different from anything else he did',[11] and this is true in several respects.

20
Saltash c.1928–30
Oil on watercolour
board
75 × 53 cm
Kettle's Yard, University of
Cambridge

21 *Above right*
Three-Masted
Schooner near a
Lighthouse c.1928–30
Oil on watercolour
board
53 × 75 cm
Kettle's Yard, University of
Cambridge

In the upper part a river is crossed by the great bridge silhouetted against a rich green hillside in forms characteristic of Wallis. However, the improbably high houses, whose rooftops Ede likened to the 'wings of birds in flight',[12] depart from his conventions as does the headlong perspective to a ship seen stern-on. Hesitation in the handling (especially where traces of pink are discernible in the windows) also suggests that he was taking up where another had left off in reusing a salvaged artist's watercolour board. This may have come from his London connections, as it was made by J. Bryce Smith Ltd, a supplier used by Nicholson. The supplier's stamp remains visible among the yardarms of the *Three-Masted Schooner* now separated from the reverse. There is little question that the whole conception of this second painting is Wallis's: with its attention to the detail of the rigging and the deck, and the setting within the harbour (which has the lighthouse and steps associated with St Ives). As already noted, it bears a resemblance to one of the illustrations in the book about sailing ships that Nicholson gave Wallis in late 1928.

The frugality which compelled Wallis to use both sides of this board brought together these complementary images. The *Three-Masted Schooner* may be regarded as a more majestic version of the earlier single schooners, but the compositional complexity of *Saltash*, like *Seascape*, suggests a greater artistic ambition. This may be related to the encouragement of Ben and Winifred Nicholson, Wood, Sealy and Ede. It reflected a greater narrative confidence, as Wallis prepared to instill more detail into the same limited confines. He seems also to have ventured from his concentration on the sea at this point to take on inland subjects, as an untitled landscape bisected by a road also belonged to Christopher Wood.[13]

The sea is not visible from Wallis's house as Harry's Court shields it from Porthmeor Beach to the north and several streets lie downhill to the harbour to the south. Opposite his house is The Digey, the street where he bought his paints and where he was knocked down in 1937, parallel to which is Bunker's Hill. A few steps away is Porthmeor Square where the peculiarly shaped 'Old

House' stands (now called Norway Cottage) which appears in many of his paintings. It is remarkable for its door rising between the first floor windows and the additional angled wall of the abutting house to the left. Wallis invariably presented the view available from his own front door. The passage to the right of the Old House was often included. He told Peter Lanyon that his brother Charles lived in the tiny house placed down this passage;[14] this act of belittling may conflate Charles and his step-son Albert Ward who lived in Bunker's Hill, both of whom were targets of family feuds. It is significant that painting thus gave Wallis fictional power and satisfaction where he lacked it in reality.

In *White House and Cottages* (fig.23) and *St Ives* (fig.22) the arrangement of the streets around this nodal point is flexible. In both paintings, the old house occupies a position slightly to the left of centre, with its peculiar windows and tiny neighbour. The streets are unexpectedly blue, and their topography works more as a remembered route than a plan or view. *St Ives*, using the brown of the card, allows a central view to the chapel on the Island at the top of the composition, so that the arrangement of houses in a sense leads in that direction. Nicholson, who was the first owner of the painting, asserted that he was given it in 1928, although it appears more sophisticated than *Schooner and Lighthouse* (fig.9).

Several other paintings feature the Old House. One, *Houses at St Ives, Cornwall* (fig.24), uses an outline style which may be associated with early work. It was completed before 1933 when it was photographed in Nicholson's studio.[15] The streets again buckle round as if leading in particular directions. The painter's own cottage must be one of those in the top left near the gas lamp; this seems modestly anonymous until one remembers that he probably knew the occupants of all the houses that he shows. Another arrangement, reminis-

22
St Ives c.1928
Oil on card
25.7 × 38.4 cm
Tate Gallery

23
White House and Cottages c.1930–2
Oil on card
20.2 × 26.5 cm
Kettle's Yard, University of Cambridge

24 *Right*
Houses at St Ives, Cornwall c.1930–2
Oil on card
26.7 × 31.8 cm
Tate Gallery

cent of *St Ives* in its portrait of the building, features according to the inscription on the back *'The Hold House port meor square island port meor Beach'* (fig.25). Above the Old House is the Island shown as a curious protuberance which at once conveys the rocks at the end of Porthmeor Beach and the plan of the promontory. Wallis marshalled experience accrued over decades walking these streets: certain features are notable, others may be passed over. Barbara Hepworth recalled buying *'The Hold House ...'* from one of the painter's parcels in about 1932.[16] Interestingly, it is painted on an undated advertisement for an exhibition of the St Ives Society of Artists, showing some tenuous contact with the town's more orthodox painters whose premises were almost next door.

A number of other paintings may be dated to 1930–33. Prominent among these is *Cornish Port* (fig.26) which can be placed before 1933, when it was published in Herbert Read's *Art Now*. It is especially energetic: two luggers enter a harbour whose piers curl round to protect them from the violent seas. The boats are on different scales, the larger one fitted with a lighter and four sailors; although placed in the foreground, the smaller boat may be another (or the same) vessel further away. In common with earlier works, it seems likely that the composition began with the main boat set at the steep angle which signifies speed as well as difficult weather. The other details were arranged around it. The smaller boat labours in an appallingly rough sea; the white paint is sent pounding in on a diagonal complementary to the direction of the boats. It is the rhythm of these elements that proved attractive to Nicholson and Read.

The widening scope of his works is also indicated by the list of descriptions sent to Ede probably around February 1934:

Island Port Mear Beach
The old House in poart mear square
and a Bit of Back Road
The Next is The Harbour
and The old Sayne Bauts
and Two Saynes shoot with pilchers
What used To Be[17]

The former may be *White House and Cottages* (fig.23): the latter is either *Harbour with Two Lighthouses and Motor Vessel* (fig.28) or, more likely, *St Ives Harbour and Godrevy* (fig.27), two of Wallis's earliest datable summaries of the harbour. Both show the same modification of the Bay which – like Mount's Bay in other works – is made angular to fit the card. St Ives harbour occupies the lower left quarter, with Hayle estuary at the right and Godrevy Lighthouse above. The structure of the port is revised (with the West Pier parallel rather than at right angles to Smeaton's Pier), but the recognisable details remain: the (now-ruined) angled wooden pier beyond the contrasting lighthouses of Smeaton's Pier, the boats beached at low tide, the seine nets holding fish off Porthminster Beach. The complex scene has been constructed through a loose geometry which orders the whole into a balanced composition. *Harbour with Two Lighthouses and Motor Vessel* uses a similar milky blue to that in *White House and Cottages*; by contrast *St Ives Harbour and Godrevy* is more energetically worked, with the beaches touched in ochre and the sea in the strong blue used for Mount's Bay. It is likely that the vertical version of this scene, *St Ives Harbour and Godrevy Lighthouse* (fig.29), also dates from this moment. It has the same colouring, employed in swinging the harbour round to a central position at the top and channelling the Bay into a strip to the right

27 *Above*
St Ives Harbour and Godrevy
also known as
Three Ships and Lighthouse c.1932–4
Oil on card
32 × 46.5 cm
Pier Gallery Collection, Stromness

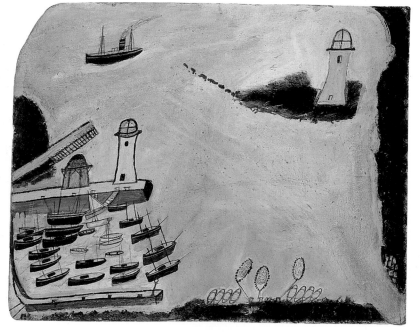

28
Harbour with Two Lighthouses and Motor Vessel c.1932–4
Oil on card
51 × 64 cm
Kettle's Yard, University of Cambridge

29 *Right*
St Ives Harbour and Godrevy Lighthouse
c.1932–4
Oil on card
64.1 × 45.7 cm
Courtesy Crane Calman Gallery, London

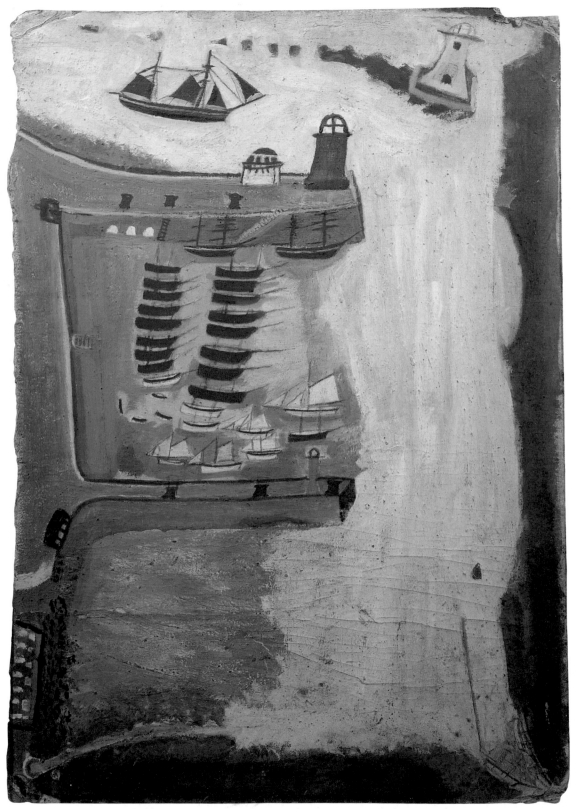

49

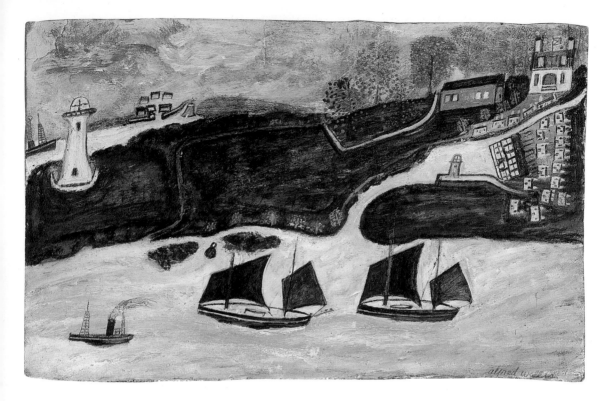

topped by Godrevy Lighthouse. The dating is generally supported by the fact that it belonged to Winifred Nicholson, whose contact with Wallis dwindled after her move to Paris in 1933.

Godrevy plays a pivotal role in the bay and in the composition. It is comparable to that allotted to St Michael's Mount, but there are telling differences. Wallis's earlier paintings of Mount's Bay seemed to reflect his experience: his viewpoint was close to the waterline and then he gathered the shore around the boats. The treatment of St Ives Bay is overtly schematic with the strong structure and organisation supplying an underlying abstract geometry. It is imaginatively reconstructed in a way extending the rearrangement of the town in the Old House pictures but departing fundamentally from their singular centrality. In all these respects, the paintings of St Ives Bay are remarkable.

A further exploration of pictorial space which is often overlooked in Wallis's work is exemplified in two other paintings. *Two Ships and Steamer Sailing Past a Port with Red Trees* (fig.30) – yet another picture to have belonged to Ben Nicholson – demonstrates a clear attempt to depict depth through diminution. Lacking a dominant ship, the intricate coast is crammed with buildings and trees which, with the exception of the two houses at the top right, recede with the contours of the peninsula. This is not achieved in an orthodox way, but appears to be Wallis's approximation of such conventions. Something of this is also found in the background of the elaborately entitled *'Penzance Harbour, Newlyn Harbour, Monsall Island, The Mount, Porthleven and Mullion nr Lizard, The one Entren the harbour is a revenew Cutter from Penzance'* (fig.31). It features the same simple luggers and, in the heavy solidity of the manned 'revenew cutter', bears comparison with the *Cornish Port* (fig.26). Scale lends the cutter a required official importance, as it dwarfs the port and anchored

30
Two Ships and Steamer Sailing Past a Port with Red Trees
c.1932–7
Oil on card
26.3 × 41.1 cm
Kettle's Yard, University of Cambridge

31
'Penzance Harbour, Newlyn Harbour, Monsall Island, The Mount, Porthleven and Mullion nr Lizard, The one Entren the harbour is a revenew Cutter from Penzance'
c.1932–7
Oil on card
20.3 × 25.4 cm
Cornwall County Council

ships. It suggests the power of the customs officers who thoroughly exercised their right to search houses for contraband.[18] Through this combination of telescoped scale and imaginative disposition, the painter managed to capture the centrality of the event within the busy shipping of the whole bay.

The period 1932–7 was probably Wallis's most productive but, perhaps because of this, it is difficult to assign paintings to particular moments. The parcels 'criss-crossed and knotted with a thousand pieces of string' were sent to Nicholson and Ede as soon as the paintings were dry.[19] The majority of these were straightforward. Among them are three that may be picked out for the similarity of their unmodified square supports each studded around the edge with nails. The stability of each composition was generated by Wallis's sensitivity to these dozen nail heads, which provide a constellation of points within which the details are arranged. The sails of *Sailing Ship* (fig.33) establish an inevitable triangulation. The near-vertical mast seems to yield to the pressure of the emerald outcrop which tips the boat back in the brown water. It is datable to around 1932, as it may be the work that Barbara Hepworth gave her cousin for Christmas that year.[20] The square format is varied in two related paintings of double-funnelled steamers: *Two Boats Moving Past a Big House* and *Land, Fish and Motor Vessel* (figs.32, 34). The former includes a fishing boat and a country house – a rural Old House – unexpectedly served by a bus parked near four gigantic birds. In *Land, Fish and Motor Vessel* a related steamer seems to have ventured into more primordial waters, as huge benevolent fish surface below the cliffs. The reliance on horizontal and vertical details relates to the nails, which may have served as the essential preliminary blemish.

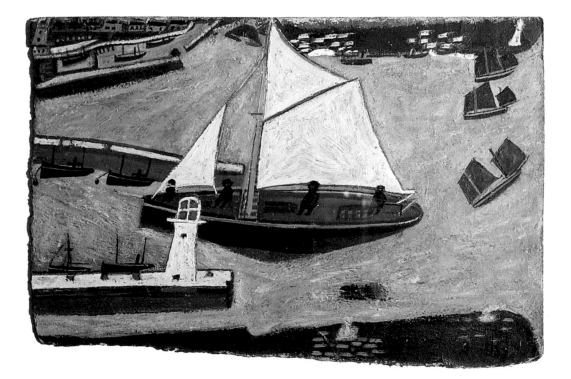

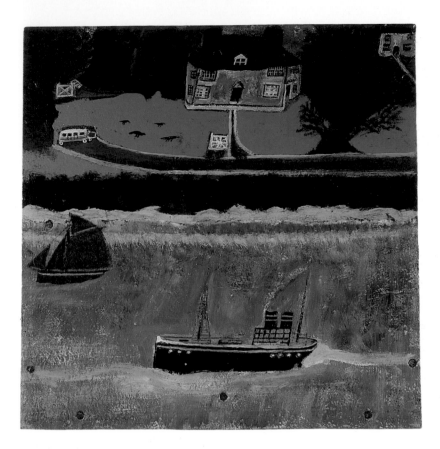

32
*Two Boats Moving
Past a Big House*
*c.*1932–7
Oil on card
38 × 37 cm
Kettle's Yard, University of
Cambridge

33
*Sailing Ship c.*1932
Oil on card
27 × 32 cm
Collection of Jack Hepworth

34 *Right*
*Land, Fish and Motor
Vessel c.*1932–7
Oil on card
37.5 × 37.4 cm
Kettle's Yard, University of
Cambridge

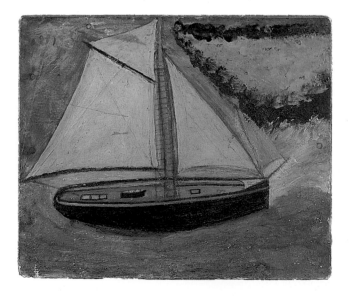

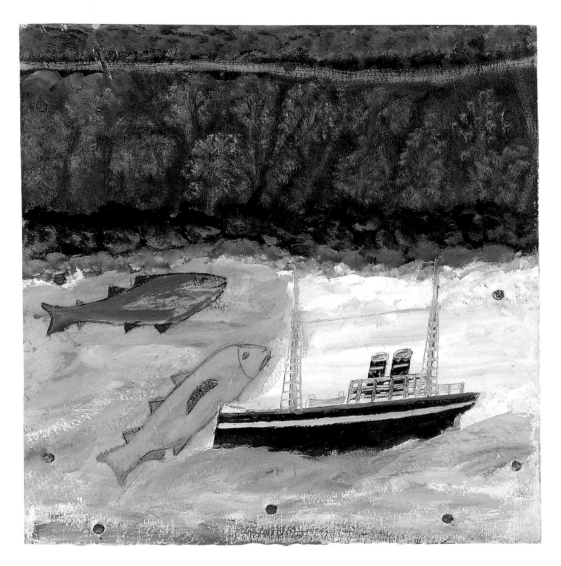

The drawn fish in *Land, Fish and Motor Vessel* may be compared to those in *Fishes and Lobster Pots* (fig.12). The unexpected monochrome image of two large and half a dozen small fish was achieved by rubbing the white into the black paint, and the details were drawn both in paint and then in negative with a pencil. The effect is strangely ghostly. The card is notable for its casual cropping and buckling, as well as the two trench folds running the full width and seven staples remaining along the upper horizon. These remnants of the box's function shepherd the forms of the composition: only the line of black water breaks above the folds, but the buckled corners hold in the pots to the left and the angry little fish to the right. The effect suited Wallis's purpose exactly, as this is probably the painting described in April 1936 as: 'The one with The CraB pots and fish is serpose To Be at The Bottom'.[21] The silvery gloom of the painting is a convincing vision of the colourless glow of fish on the ocean floor. In both paintings, the fish may be related to those identified by Wallis as the 'souls' of the boats. This idea is at once charmingly folkloric and sternly religious; it also suggests the symbiotic relationship between fisherman and fish, livelihood and its acute dangers.

Rowe, whom Wallis told about the fish-souls, was also apparently told that 'no boat should have a motor';[22] however, motorised boats of various types feature regularly in his paintings. One was even identified by Ede as a 'P&O Boat'.[23] The related *Trawler Passing a Lighthouse* (fig.35) seems to be mis-named, as it is probably a cargo boat turning into port. Like so many, it almost lies on the diagonal of the card, dividing the blue-green sea from the sandy land superimposed above. The sea was heavily scumbled over the smoothly painted hull, a slight dryness of the paint allowing the suggestion of the break-ing edge of the wave. The port was drawn in the same style as the contempo-rary paintings of St Ives, and the rough texture underlies the shore which has been indented around the steamer. This vision of the land – with what appears to be a great domed building (but may be rows of tiny houses in a courtyard) and the triangular black trees – is rather exotic. It may be appropriate, as the white 'H' on the funnel is the insignia of the local Hain Steamship Company, which traded around the world and the progress of whose ships was listed in the local paper.

The majority of Wallis's paintings addressed subjects closely linked to the sea. They seem to be more an assertion of his individual powers than an attempt to convey a message. Nevertheless, it should be recognised that they may deliberately convey religious views or nostalgia in the face of progress. It is

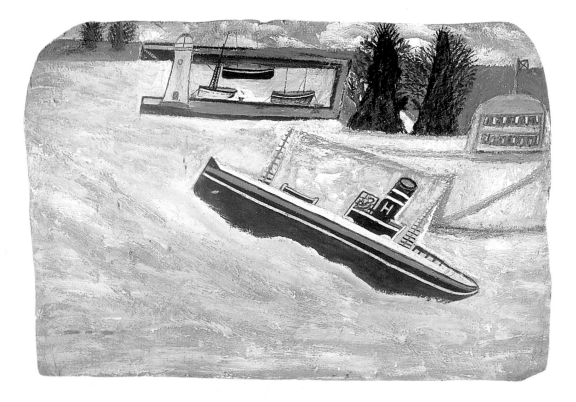

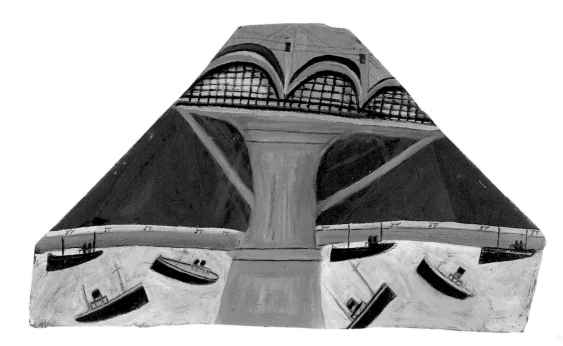

35 *Left*
Trawler Passing a
*Lighthouse c.*1935–7
Oil on card
36.8 × 54 cm
Dartington Hall Trust

36 *Above*
Boats under Saltash
*Bridge c.*1935–7
Oil on card
30 × 50 cm
Kettle's Yard, University of
Cambridge

37
Boats before a Great
*Bridge c.*1935–7
Oil on card
36.7 × 39.2 cm
Kettle's Yard, University of
Cambridge

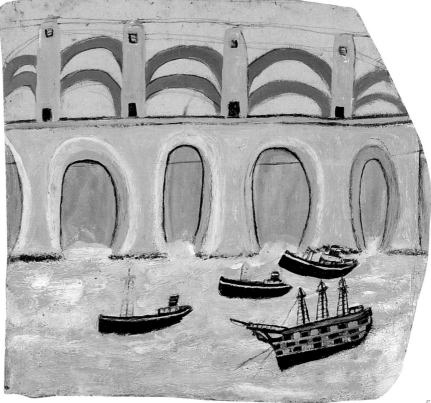

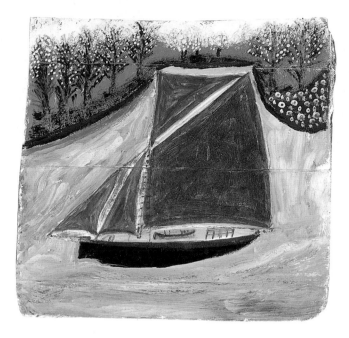

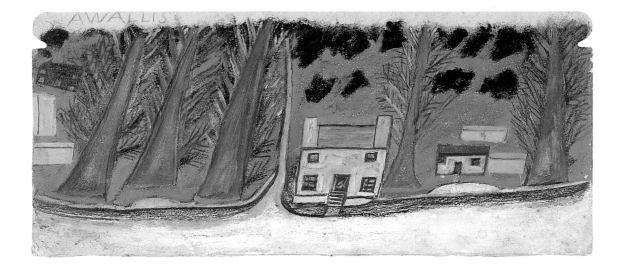

also likely that, with the returned works from London and the occasional visitors, Wallis had a fairly shrewd idea of the reaction of his audience and reworked themes which both he and they considered successful. Some of the most inventive feature a bridge generally identified with Saltash bridge, which the painter knew as a child and saw again as a sailor. It is sometimes shown as an intrusion of industrialisation into the landscape, but always serves as a meeting point between different zones – between land and water, rail and ship, and geographically between Devon and Cornwall. Why he should return to it in memory is not known, but it may coincide with his statements to Ede about his birth in Devonport.

Perhaps the most remarkable of these bridge paintings is *Boats under Saltash Bridge* (fig.36), painted on a roughly cut triangular card. Its cross-cut corners slant subtly to the right for which compensation is made in the composition. Although there is a perfectly balanced painting of a ship on the reverse, the choice of the bridge was inspired. The form of the structure was echoed by the shape of the card which also conveyed its enormity by only providing a glimpse. Establishing three horizontal fields tied to the peculiarity of the support, Wallis made the two grey triangulating stays reflect the angle of the sides. Incident is pressed to the top (the laborious working of the meshed arches) and bottom (the bobbling ships), helping to give the bridge scale. The colour scheme is closely limited, passing from white through green and greenish grey to the black of the ships' hulls. This is enlivened by the glow of orange card allowed to appear above the arches. The striding bridge is a peculiar and compelling image. It is not entirely benevolent here and Wallis's sympathy seems to lie with the rocking steamers. A different bridge proves rather more friendly in *Boats before a Great Bridge* (fig.37). The composition is again divided into three, although on a more orthodox format; the structure and superstructure occupy the upper two-thirds, with the boats again bobbing. The lighter palette establishes a lighter mood, as the arches vary awkwardly but the ships line up as the heavy working of the sea skillfully expresses the towing current. The galleon anchored in the foreground has been linked to those used for naval training near Devonport.[24]

38
*Sailing Ship and
Orchard c.*1935–7
Oil on card
21.1 × 21.8 cm
Kettle's Yard, University of
Cambridge

39
*Landscape c.*1935–7
Oil on card
30.5 × 45.8 cm
Courtesy Crane Calman
Gallery, London

40 *Above
House with Trees
c.*1935–7
Oil on card
17.4 × 40 cm
Kettle's Yard, University of
Cambridge

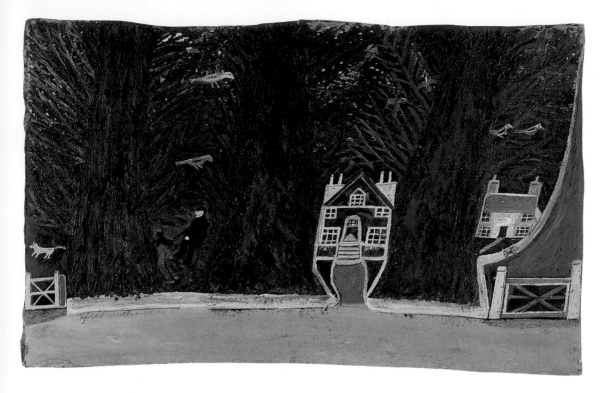

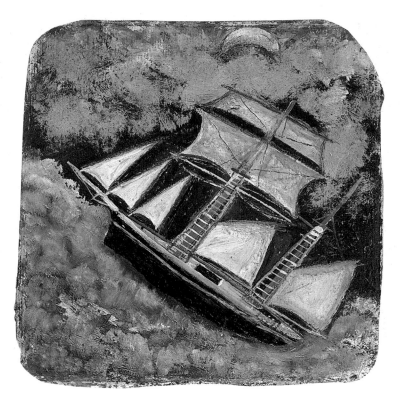

Wallis's paintings of the land are considerably less frequent and often rather peculiar. If his presumed period at sea is now considerably reduced from previous projections, he nevertheless seems more at home with it. The inland works may be divided roughly between those, such as *Landscape* (fig.39), in which details of houses and fields are stacked up as if seen partially from above, and those filled by gigantic trees. Formally, both devices show Wallis seeking an equivalent to the sea so that he could fill the composition with brushwork. The impression is that the detail of the countryside made him uneasy and restricted the breadth of his handling.

One of these paintings is that simply called *Cottages in a Wood, St Ives* (fig.41). Marvellous and frightening trees tower above an improbably small wall closing out the background with their mass of tiny branches. By these three trees Wallis conveys a forest. Two houses, primly outlined in white are thrust back into this primeval scene but the frailty of their drawing reflects a temporary state of intrusion into nature. Strange birds perch watchfully or take flight. In a dark hollow below the moon, a dog arches back argumentatively and a man, with white face and hand, carries a leash or a gun. A white animal stands beyond the left tree; it seems to be a fox which has outwitted the dog. The result is a nocturne of immense power because of its mystery. There is a narrative of disjointed threads. Watching, waiting, hunting, escape: all these feature in a zone closed off from suburban tidiness. The area beyond the wall is like the painter's psyche, whilst the area in front suggests conformity summarised in the signature – 'Alfred Wallis St Ives' – calm and cursive on the road below the left-hand tree. What is so cogently expressed here – the oppression and mystery – is also hinted at in other works in which trees and animals feature. In *Houses with Animals* (fig.13), flocking animals disconcertingly go about their

59

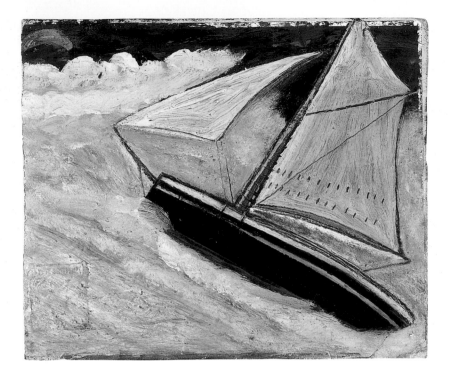

business irrespective of man. In other paintings, such as *Trees and Cottages* (fig.42), the trees reappear as overbearing guardians.

Like *Cottages in a Wood, St Ives*, a surprising number of Wallis's paintings are set at night, indicated by the presence of the crescent moon. Mullins noted the peculiarity of its upturned position.[25] It may be presumed that the moon had long been a helpful guide to the painter, both at sea and in crossing Penwith at night. The streets of St Ives continued to go without gaslight during the summer and on moonlit nights, until the coming of municipal electricity with the Second World War.[26]

A number of his small square paintings are set at night and feature single ships mounting alarming waves. The ships in *Schooner under the Moon* (fig.43) and *Small Boat in Rough Sea* (fig.44) seem to relish the challenge. The dark skies exaggerate the focus and struggle. *Schooner under the Moon* pitches steeply on a brown sea marbled over black and green. The vessel in *Small Boat in Rough Sea*, though turning over in the churning water, is more assured than most. The card again helped to generate the composition, as the boat rises above an embossed square in the bottom right. Part of the lettering is just legible, asking rhetorically 'IS IT BRITISH?'; this dates the card to the 'Buy British' campaign responding to the economic crisis of the early 1930s.

Such compositions came out of Wallis's imagination and a response to his materials, although his themes clearly did come from observation. This may be what he meant by his nostalgic declaration that he painted 'what use To Be … hout of my mery [memory]'.[27] The paintings protest against the passage of time and ideas of progress. The past provided a place of retreat in which Wallis could be the heroic mariner that his London admirers took him to be. His statement was, perhaps, both a protestation of authenticity and an assertion of the validity of his memories.

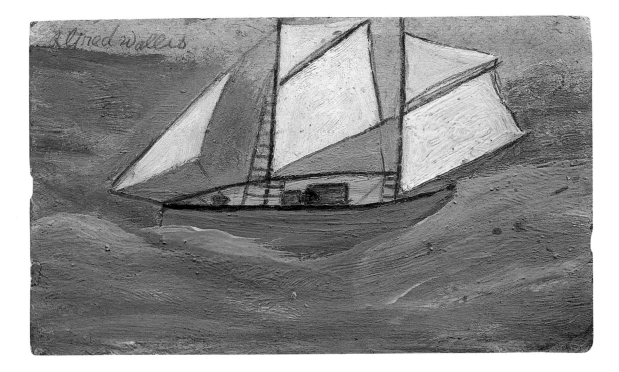

44 *Left*
Small Boat in Rough
Sea c.1936
Oil on card
19.5 × 23.2 cm
Kettle's Yard, University of
Cambridge

45
Ship in Rough Sea
c.1935−7
Oil on card
11.5 × 19.2 cm
Arts Council of England

46 *Right*
Voyage to Labrador
c.1936
Oil on board
36.8 × 38.7 cm
Tate Gallery

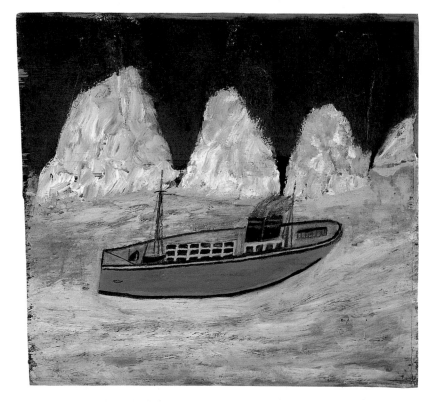

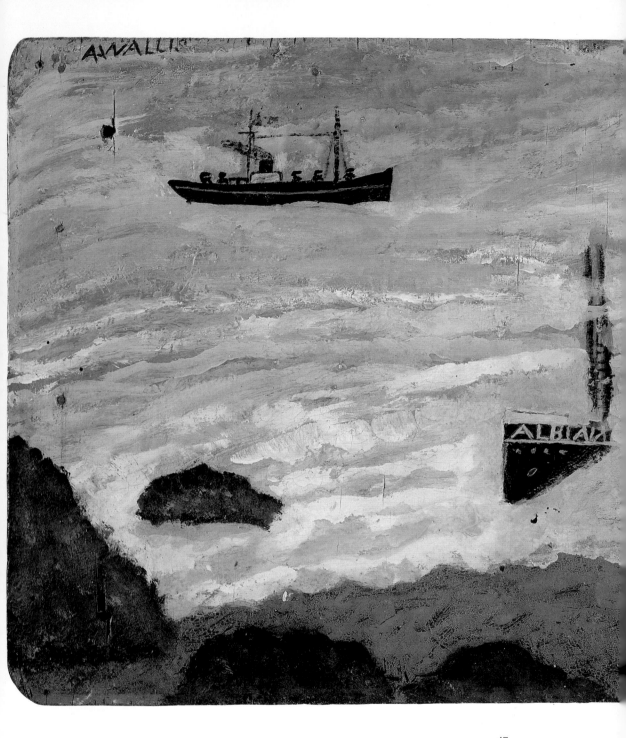

47
The Wreck of the Alba
*c.*1938–40
Oil on board
37.7 × 68.3 cm
Tate Gallery

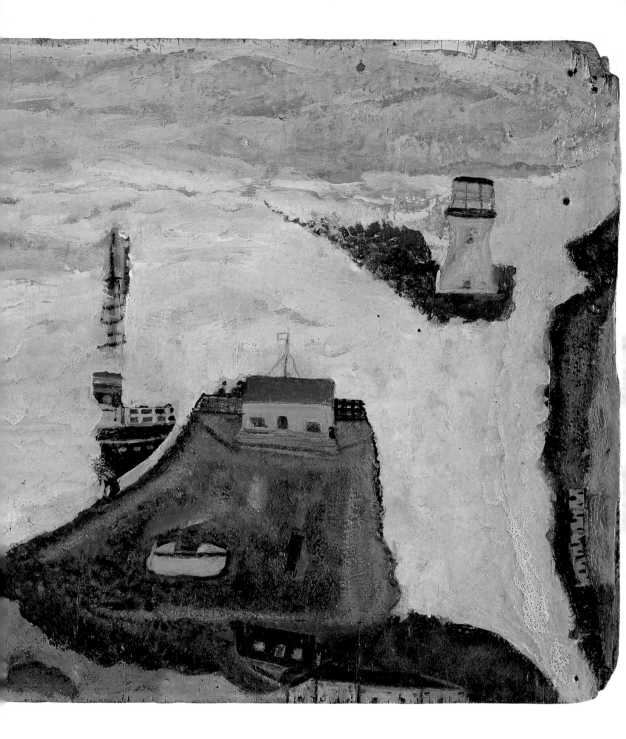

Wallis also individualised his past through his painting. He is now known to have crossed the Atlantic to Newfoundland, and he certainly conveyed an intrepid mood in a deluge of colour and brushwork as steely grey seas and skies threaten deadly storms. The densely energetic handling which captures this atmosphere is found in *Schooner under the Moon* and *Small Boat in Rough Sea*, and accords with *Voyage to Labrador* (fig.46), a painting datable to around 1936. An orange sided steamer rides the ocean, two black funnels industriously pumping smoke. It skids on a delicate green line through the rough white sea laid over blue and yellow. Behind, icebergs pile up in precarious brushstrokes against the black and green depths of night. At one stage the icebergs reached to the top of the plywood board. In modifying the composition, Wallis curiously domesticated them whilst maintaining their looming presence. Any scepticism voiced over whether these shapes really were intended to be icebergs seems refuted by the evidence of the *Belle Adventure*, and Adrian Stokes recalled that the painter told him it represented his 'impression of a voyage to Labrador'.[28] Stokes bought it and *Schooner under the Moon* in December 1936.

The struggle of shipping is a constant in the paintings, perhaps because both ships and wrecks had been part of Wallis's business. As the earliest of his descriptions of a painting featured a grounding, it is perhaps not surprising that the wrecking of the *Alba* became the theme for a series of paintings (figs.47, 49). It exposes issues which may be present but obscured in other works. The paintings may be securely dated by the wreck of the Panamanian freighter on the rocks off the Island on 31 January 1938. In at least two, Wallis wrote the name on the prow of the ship: 'alba' on one and (more elegiacally) 'ALBIAN' on another.

The story was immediate and tragic. The *Alba*, laden with Welsh coal and bound for Civitavecchia tried to turn back into St Ives Bay to seek shelter, finding the storm to the south too terrible to ride out. According to the subsequent inquiry, the recently reduced light in Godrevy Lighthouse was too weak, and the captain thought that the shore lights on Porthmeor Beach were those of the harbour and ran aground on the rocks in seeking an anchorage. The St Ives lifeboat managed to take the men off in difficult conditions, but was overturned by a wave on rounding the freighter's hull. It too was swept onto the

48
Three-Master on a Stormy Sea c.1936–8
Oil on card
17 × 36.9 cm
Kettle's Yard, University of Cambridge

49
The Wreck of the Alba c.1938–40
Oil on card
26.5 × 33.5 cm
Kettle's Yard, University of Cambridge

rocks. The men spilled out and floundered to safety on the rocks and the beach, aided by the townspeople who waded into the rough seas to save them. However, five of the Hungarians among the crew were lost. Two bodies were not recovered. The epic of men pitted against the elements was reinforced by the special supplement of the *St Ives Times*[29] and a BBC radio report, as well as the official enquiry and the thanks of the Hungarian government. The wreck of the *Alba* remained to be broken up by the waves. Astonishingly, the upper parts of its boilers still resurface at the lowest tides. In 1939, the following year, all but one of the same lifeboat crew were lost in another desperate rescue.

Wallis's paintings capture the wreck and the wrecking by showing the central portion of the hull literally painted over as it is overwhelmed by the sea. The fact that he included both the lighthouse and the stranded lifeboat in *The Wreck of the Alba*, suggests that he read the detailed reports as well as observing the events himself. Through the series he returned to the same scene in order to summon up the force of the pounding waves through the energy of his brushwork, and icy sea in the modulations of whites. The element of reportage in the painter's choice may be peculiar to this case. However, other paintings suggest that the experience was not simply confined to 'what used To Be', but moved seamlessly into the present. Wallis recorded the vanishing past, but also captured the receding present.

The series of *The Wreck of the Alba* may therefore be said to fix a particular event and to be an example of a wider practice of repeating material until it was mastered, until the power of the painting matched the power of the subject. It is not possible to be sure about what Wallis thought of the *Alba*. The wrecking was a disaster, but as a rag-and-bone man, such events had provided his source of livelihood. Here, long retired, he may have seen in it the struggle between the ingenuity of man and the power of the elements – or of God, as he would surely have seen it. Without too much exaggeration, these may be seen as epic paintings of fatality, and of the scale of man's endeavour dwarfed by

that of the natural world. Significantly, this coincides with the painter's own decline and sense of persecution following the car accident in The Digey. Furthermore, in naming the ship 'ALBIAN' in the widest painting, Wallis evoked 'Albion', a familiar name for Britain. Although probably ignorant of Blake's allegorical use of the name, Wallis was surely aware of the potential for such allusion especially in view of the returned threat of war.

That Wallis made the *Alba* paintings during his last years – the version on plywood was bought from him by Brett Guthrie on 7 May 1940 – is remarkable as he was, by some accounts, increasingly disturbed. Many works of the late period are hurried and barely resolved, some use unexpected flashes of colour, whilst others seem to have been abandoned in the process of filling in the pencil work. On good days he was still able to produce paintings of considerable ambition and which he himself thought as 'good if not Better i have don'.[30] When Peter Lanyon visited him in 1940, he was 'allowed' to buy the painting of *Saltash Bridge* (fig.50) only on promising to read the Bible every day while he was in the services.[31] Executed on a piece of table top, it returns to the theme of the bridge to establish a balance between the linked shores with their characteristic trees and single houses. By pressing the bed of the bridge high into the top of the board – apparently responding to a slight unevenness there – he signified its grandeur. More so than other images of the bridge, this seems to convey a sense of passage across borders. In the shadow of the bridge, the recollection of the chain ferry demonstrates Wallis's uncanny memory for detail.

If it is believed that Alfred Wallis painted out of compulsion, then his will to work up to the last weeks of his life – even in the reduced means of drawing (fig.51) – was a sign of his continuing search for an outlet for his imagination.

50
Saltash Bridge
c.1938–40
Oil on board
32.4 × 106.7 cm
Private Collection

51
Orange Ship with Five Fish c.1941–2
Crayon on paper
21.5 × 27.5 cm
Kettle's Yard, University of Cambridge

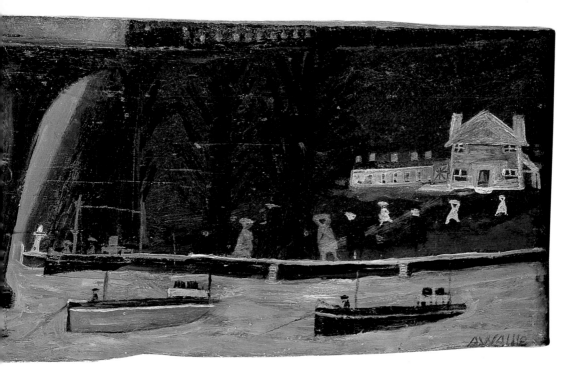

By these means he secured a place for himself in a wider sphere, not as the deaf and cantankerous ex-rag-and-bone man but as a genuinely creative man able, through the imaginative manipulation of limited materials, to give a compelling account of a life that he might have led.

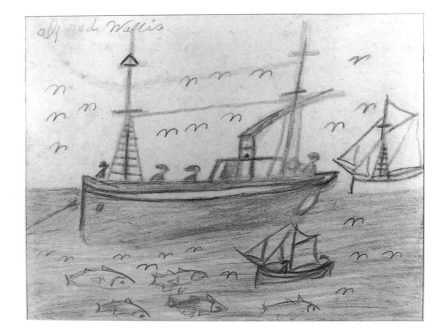

4
'Artist & Mariner'
The Myth of the 'Primitive'

Like his life, Alfred Wallis's tomb is different from all others in St Ives. The tiled grave covering in Porthmeor Cemetery bears the white inscription: 'ALFRED WALLIS / ARTIST & MARINER / 1855 aug 18 aug 29 1942 / INTO THY HANDS O LORD' (fig.52). A tiny man climbs the steps through the door of a tall white lighthouse. The tomb decoration was made by Bernard Leach; though in- termittently resident in St Ives since 1920, by his own account the potter had never met the painter.[1] Berlin — another who did not meet Wallis — notes, without explanation, that Barbara Hepworth 'refused' and he himself failed to carve a stone, both perhaps because of wartime shortages of materials.[2] Nev- ertheless, the glazed tomb records the sympathy of his artist admirers and their belief in his individual powers — what Naum Gabo called on his wreath 'being an artist without knowing it'.[3] The sandy yellows and earthy reds are the potter's equivalent of Wallis's more virulent colours. The inscription makes reference to Coleridge's 'Ancient Mariner', whilst the figure entering the lighthouse evokes Blake's *Death's Door*.[4] Both place Wallis within the tradition of British Romanti- cism, which took on special significance in the climate of self-reliance and artistic neo-Romanticism of the Second World War. In his sustained creativity, Wallis could be a symbol of native resilience. He is both ancient and modern: he enters the isolated lighthouse with the possibility that his example could light the way for others. The fact that the inscribed date of birth is incorrect is symp- tomatic of the myth already obscuring the biography. As with all myths that of Wallis reflects his perception by others. It may be traced through three overlap- ping stages: the climate of his 'discovery', the wider reception of his work, and his posthumous reputation. All are bound up with the mid-century notion of the 'primitive', so that the development of the Wallis myth reflects the shifts in this interest.

It has long been recognised that the work of Ben and Winifred Nicholson and Kit Wood already had a quality of assumed naïveté before they met Wallis.[5] This was true of other members of the 7 & 5 Society, including Frances Hodg- kins and Cedric Morris who had both lived in Cornwall. Morris subsequently claimed to have known Wallis before Nicholson met him,[6] although there is little evidence for this; instead, he certainly knew the other local and untrained painter of harbours, Mary Jewels. Colin Sealy, who worked in a Cubist vein, was also a member of the 7 & 5 Society until taking a studio in St Ives in 1927; as noted, he visited Wallis in 1928. These artists were, therefore, predisposed to Wallis's sort of personal view of reality, and his work provided a vital example. Winifred Nicholson's St Ives paintings, such as *Drying Pilchard Nets*, 1928 (fig.53) displayed a new energy, whilst Ben Nicholson's *Porthmeor Beach, St Ives*, 1928 (fig.54) shows an adjustment of his own sophistication. Wood could admit of such paintings as *Porthmeor Beach*, 1928 (fig.55): 'more & more

52
Bernard Leach
*Grave of Alfred Wallis,
Porthmeor Cemetery,
St Ives*
Glazed tiles

influence de Wallis, not a bad master though'.[7] Such works dominated the 1929 exhibition of the 7 & 5 Society in which Wallis's work featured as a validating authenticity. As evidence of a broader tendency, it is interesting that the exhibition also included a work by another untrained painter – also a contact of Ede's – the teenage Winston McQuoid; he painted childhood memories such as *Landscape with Bridge* (fig.56), the atmosphere and handling of which bear some comparison with Wallis.

The wider context for this reception lay in a general re-evaluation of 'primitive' art earlier in the century. As the expectations of art shifted from imitation to expression so the work of such 'modern primitives' came to be valued. This reflected a deeper divergence between the academic belief that art could only be taught and the disenchantment among young artists trained within this system with its moribund conformity. Their support of 'primitives' was, therefore, part of a wider polemic in which the untrained artists served as exemplars rather than participating directly.

Central to this development was the reputation in Paris of Henri 'le Douanier' Rousseau. The poet Guillaume Apollinaire claimed that he 'had such a strong sense of reality, that sometimes when painting a fantastic subject, he would become terrified and … would be obliged to open the window'.[8] The belief that such artists moved seamlessly between reality and the illusion of art was part of their attraction. There was a strong measure of paternalism in this attitude, but there is no doubt that it was combined with awe. Picasso, Braque and Robert Delaunay all championed Rousseau's work before the First World War, and following his death at sixty-six in 1910, a special exhibition was organised at the 1911 Salon des Indépendants. Rousseau's reputation reached unforeseen

heights in the mid-1920s. *The Snake Charmer*, 1907 (fig.57) was accepted by the Louvre (although it was not given for another decade), and in 1926, the same year as his first London show, *The Sleeping Gypsy* sold for a record sum of 520,000 francs amid repeated rumours that it had been faked by his admirers.[9] His posthumous success paved the way for others. These included the painter of ships, Paul-Emile Pajot, who exhibited in Paris in 1925, and Séraphine Louis, a maid in Senlis who painted entangled flowers with materials supplied by the collector, Wilhelm Uhde. The gardener-painter, André Bauchant, was promoted by the periodical *L'Esprit Nouveau*, whilst the 'Palais Idéal', a massive building constructed by the country postman Ferdinand 'le Facteur' Cheval, was championed by the Surrealists.

It seems notable that these artists were born in the middle decades of the nineteenth century, and took up art usually on their retirement.[10] They emerged from a sector of the working classes and petit bourgeoisie which retained residual roots in a pre-industrial era. However, their lives were overtaken by industrialisation and their art most often expressed a nostalgia for this lost past. Living longer than previous generations, they found themselves isolated within the community. Their work achieved acceptance in conjunction with and partly because of the connections with familiar folk art traditions, such as painted shop signs or model making.[11] For some, this could convey national qualities – which became a dangerous gloss in the inter-war period of political polarisation. Acceptance also

came because the work was modest in its pretensions and made out of the sheer enthusiasm of the individual.

It is telling that the concept of the 'primitive' placed such artists alongside others with whom they shared only the lack of academic training. The creative necessity was compared to the obsessive art of the insane studied aesthetically and clinically in Hans Prinzhorn's *Bildnerei der Geisteskranken*.[12] Exhibitions of childrens' drawings were held, and the works also studied for artistic and observational reasons, notably by the Austrian educationalist Franz Cizek. However, the disparate term 'primitive' was primarily applied to art outside the European tradition, encompassing the pre-classical sculpture of the ancient world (Cycladic, Etruscan, Sumerian), 'Italian primitives' such as Giotto and Duccio, and the arts of the Far East, Africa and the Americas. The disregard for their contexts and purposes has since raised irrefutable accusations of 'cultural colonialism'. More pertinent to the moment was the fact that this curious combination of the research of archaeologists, anthropologists, psychologists and art historians implicitly demonstrated a disenchantment with the fruits of civilisation.

The 'primitive' was thus defined as a negative of the European norm, divided by time or place from – but exploited by – 'advanced' culture. Children were an unformed state of the adult, so, the argument went, 'primitive' societies were striving towards western civilisation. Painters such as Rousseau and Wallis have been termed 'endogenous primitives', because they were within but not of the cultural system.[13] If it took the avant-garde to review the quality of the work produced, it would take the demise of colonialism to begin to strip back some of these preconceptions and to fashion more subtle understandings. In the case of the 'modern primitive', a narrow path led between frequent comparisons to pre-Renaissance masters and unspoken comparisons with the art of the insane.

This curious mixture of attitudes and forces provides, therefore, the context for contact with Wallis. As has been noted, Nicholson's gift of a book on Rousseau is significant as a point of reference. At the risk of over-dramatising it, the gift may be seen as categorising the painter. It staked the claim of the London avant-garde to his work; in retrospect, Adrian Stokes could characterise Wallis as Nicholson's 'protegé, so far as he was anyone's'.[14] In a significant objectification of his work which Wallis may have understood, his Hampstead supporters placed his painted cards unframed in careful arrangements with other objects on their mantelpieces. Almost certainly it was Wallis's example – especially his double-sided paintings, that encouraged Nicholson to consider his own boxes and reliefs in terms of their quality as object.

The extent to which Wallis was seen in the context of wider ideas of the 'primitive' is reflected in his promotion in the 1930s. Public notices of his work were rare but important, as the efforts of Herbert Read and Adrian Stokes commanded a wide audience. Read reproduced *Cornish Port* (fig.26) in his 1933 survey of the aesthetic basis of avant-garde art, *Art Now*. He explored philosophical and psychological theories, but allowed the paintings that he illustrated to speak for themselves. Wallis is not mentioned, although the discussion of 'primitive' art is pertinent. Using the term in the widest sense, Read suggested that among artists aware of recent scientific studies of child art 'there has been a deliberate attempt to reach back to the naivety and fresh simplicity of the childlike outlook'. He went on to assert:

53
Winifred Nicholson
Drying Pilchard Nets on The Island, St Ives
1928
Oil on canvas
59.7 × 73.7 cm
Dartington Hall Trust

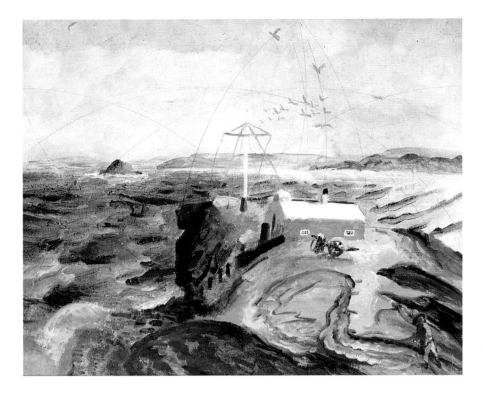

Primitive man and the child do not distinguish in our ratiocinative manner between the real and the ideal. Art for them is perhaps not so disinterested: it is not extraneous and complementary to life, but an intensification of life: a stirring of the pulse, a heightening of the heart's beat, a tautening of the muscles, a necessary and exigent mode of expression.[15]

Here the compulsion to paint is elegantly couched in terms of psychologically charged expression which recall Apollinaire's assessment of Rousseau. This state of innocence was closely parallelled by Read's subsequent quotation from Picasso: 'I don't know in advance what I am going to put on the canvas, any more that I decide in advance what colours to use'.[16] To a contemporary reader the practice of avant-garde and untrained painters must have appeared very similar.

In a 1938 text, Read mentioned Wallis in relation to an illustration of *Houses with Animals* (fig.13). The comparisons were telling: 'He is sincerely "naïf" – much more so than the Douanier Rousseau – and the approbation that his work receives from "professionals" far surpassed his understanding. His work has great charm, both in its colouring and its conception: he displays the inno-cent vision of an old man who still has the eyes of a child'.[17] Here the equation between the painter and the child allows the suggestion of sensibilities un-blemished by the decayed values of established culture. Generous though this comparison was intended to be, it restricted the possibility of the 'primitive' having some intention or purpose in his creative activity.

Adrian Stokes's book *Colour and Form*, of the year before, was of a different order. It proposed his particular view of the interrelated pictorial elements of the title, developed from earlier discussions of carving. He devoted a substantial passage to Wallis and especially to a painting he had just acquired *Voyage to Labrador* (fig.46). Concerned with composition through colour, Stokes wrote:

the old fisherman of St Ives, Alfred Wallis … often paints his seas with earth colours, white and black, colours which, if gathered up, will equal in hue or in tone or by some sort of affinity, the colour of his boats. But then he has been a fisherman all his life, accustomed to conceive the sea in relation to what lies beneath it, sand or rock and the living forms of fish. For him the colour of the sea is less determined by its glassy surface that reflects the sky. The surface of his sea, seen best on grey days, is the showing also of what lies under it, and boats are further showing compact for carrying men, an elaboration of the sea-shell, a solid darkness from depth the final fruit of an organic progression.[18]

Stokes's premise was that Wallis established a balance in his work intuitively as he had the advantage over 'more sophisticated' artists of painting out of his own experience. Of *Voyage to Labrador* Stokes added: 'two worlds of feeling are merged in this earth-coloured sea to which the boat is joined, not as one form posed in relation to another, but as a form with its roots in another, as it were, from which it grows and whose opposite nature it displays under the dramatic guise of rooted affinity'.[19] Flatteringly, he passed immediately to discussions of Picasso and Cézanne, implying their common purpose.

The support of Read and Stokes located Wallis's work within a broader culture of the times. Of necessity, their interpretations were divided from his painting as his private activity. They coincided with a gathering interest in 'modern primitives'. In May 1938, Tooth's Gallery held a show which included Rousseau, Séraphine and Bauchant, as well as Louis Vivin and Camille Bombois. Eschewing the terms 'primitive' or 'naïf', it went under the title *Les maîtres populaires de la réalité* in order to highlight the rooting of their work within a wider community. This exhibition echoed the contemporary *Masters of Popular Painting* at the Museum of Modern Art in New York, of which the 'European' (i.e. French) section was prefaced by Jean Cassou. He explained: 'Because their impulse to paint was of an absolute and unqualified purity, the feeling and taste which their work expresses are, undistorted, the feeling and taste of the class to which they belonged. They have the right to be called "artists of the people"'.[20] Such sentiments, even if in danger of being patronis-

54
Ben Nicholson
Porthmeor Beach, St Ives 1928
Oil on canvas
90 × 120 cm
Private Collection

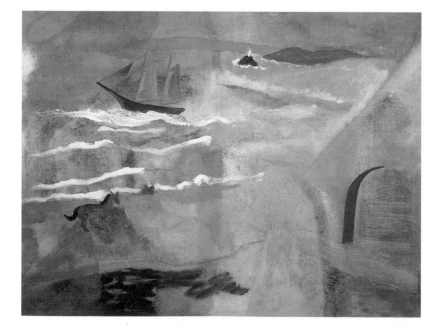

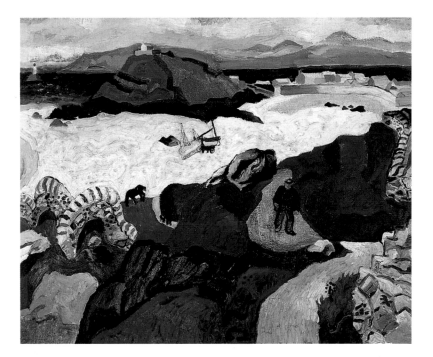

55
Christopher Wood
Porthmeor Beach 1928
Oil on canvas
46.5 × 55.2 cm
Collection of Michael
Nicholson

ing, spoke of the politicised context of European art: these artists were per-
ceived as exemplary of a latent indigenous culture implicitly contrasted to the
suppressions of art in totalitarian states.

Such 'artists of the people' also emerged in Britain. The dealer Lucy
Wertheim included paintings by Henry Stockley, a London bus driver, with
those of Wallis, Wood and others in her loans to schools and municipal gal-
leries.[21] The travelling exhibition *Art by the People*, drawn from Adult Education
Institutes around the country, reflected more directed social aspirations. It pro-
posed to 'bring home to the people themselves the kind of art that they can
produce'.[22] This approach also determined the 1938 exhibition of *Unprofession-
al Painting*, where the works of the miners of the Ashington Group were shown
alongside those of Wallis (as 'Alfred Wallace'), Stockley and others. In the cata-
logue, Tom Harrisson favoured these results over those of professionals as
they were 'painted because the people wanted to paint them'.[23] Harrisson was a
founder of Mass Observation through which everyday life in Britain was docu-
mented anthropologically, and his socio-political views are clearly evident:
'these pictures', he asserted, 'illustrate the lives and experiences of the persons
painting them, as all paintings must. And that experience is unsophisticated, di-
rectly in touch with everyday problems of normal relations, economics,
etcetera'.[24]

However progressive, the almost exclusive adoption of Wallis by the Hamp-
stead avant-garde set the painter at some remove from this vision of egalitari-
an opportunity. This impression was reinforced by Nicholson's donation of
Cornish Port (fig.26) (alongside one of his own White Reliefs) to the Museum
of Modern Art in New York in 1940. As an institution which promoted mod-
ernism, it could be pointedly contrasted with the Tate where Wallis remained
unacceptable despite Ede's best efforts. In wartime, there was also a sugges-
tion of national overtones: in neutral America, Wallis's image of a ship strug-

gling into port painted on fragile card could be read as a sign of Britain's isolated resilience. It arrived at a time when such work was enthusiastically received. When Sidney Janis reported from America in *Horizon*, his brief assessments of the work of Morris Hirshfield, Gregorio Valdes and others revealed a wealth of exhibitions of untrained artists, including *Unknown American Painters* in 1939 and a Hirshfield retrospective in 1943.[25]

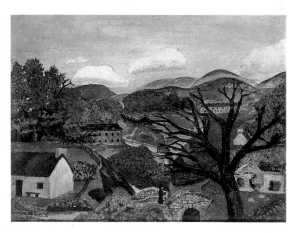

Ben Nicholson, who appeared cautious about promoting Wallis, noted the few instances of the works' exposure in his article in *Horizon* in 1943. There he took up Stokes's formalist observations on colour, memorably writing of 'shiny blacks, fierce greys, strange whites and a particularly pungent Cornish green'. He added – echoing Read's position – 'since his approach was so childlike one might have supposed that his severe selection of a few colours was purely unconscious'.[26] He concluded by returning to this perception of the 'childlike':

Wallis's motive: creating 'for company' and his method: using the materials nearest to hand is the motive and method of the first creative artist. Certainly his vision is a remarkable thing with an intensity and depth of experience which makes it much more than merely childlike … his imagination is surely a lovely thing … it is something which has grown out of the Cornish earth and sea, and which will endure.[27]

Thus Wallis was perceived as an epitome of 'authenticity', bound up with ideas of the persistence of ancient values identified with the locality. This would even lend a ritualistic aspect to the unverifiable stories of the destruction of paintings after his death, as a 'cartload was destroyed, burnt at Zennor, by the big stone there, we were told.'[28]

Tradition, innocence and locality were themes derived from the contemporary debates about 'primitives'. However positive, they reinforced associated preconceptions. It was only in Paris after the war that a more combative stance was taken by Jean Dubuffet in the 1949 manifesto *L'Art Brut préféré aux arts culturels* and his efforts to collect, publish and exhibit 'outsider' art or what he termed 'Art Brut'. For Nicholson, the 'childlike' remained an enviable state of creative purity which he recognised in Wallis, and which he and Hepworth observed in their own children during the war. Wallis was, through these attitudes, restricted to Read's 'old man who still has the eyes of a child'.

Of the painter's posthumous reputation relatively little needs to be added to the observations already underlying earlier parts of this account. The fact that Sven Berlin began his first biographical essay so soon after Wallis's death confirms the strength of his following among the younger artists in St Ives.[29] Berlin made his full-length biography, written during the war, into an epic struggle, both political and psychoanalytic. For him, Wallis was an artist of the people, as Cassou and Harrisson had defined them: a painter whose work innocently conveyed the concerns of his class. More particularly, Berlin saw the Cornish as disenfranchised, isolated in their traditions and weighed down by their religious beliefs. He added to this a powerful blend of romantic speculation and psychoanalysis: observing, for instance, the undeniably phallic forms of the painter's lighthouses but also asserting that he remained a virgin until his marriage.

56
Winston McQuoid
*Cottages and Bridge,
Ireland* 1926
Oil on canvas
38.7 × 49.5 cm
Kettle's Yard, University of Cambridge

57
Henri 'Le Douanier' Rousseau
The Snake Charmer
1907
Oil on canvas
169 × 190 cm
Musée du Louvre, Paris

Though much disputed in detail, Berlin's account placed an emphasis on Wallis in St Ives which was quite distinct from his earlier exclusive relationship with Hampstead. This reimmersion in Cornwall reinforced Wallis's pivotal place in relation to local artists associated with post-war abstraction, who saw him in a different light, recognising the power of his colour, gesture and faithfulness to the picture surface. Having failed in their attempt to organise a retrospective, Nicholson and Lanyon included a single Wallis in the first exhibition of the Penwith Society of Artists in 1949, and his paintings continued to appear as talismans; a week-long exhibition was organised in 1959. Whilst Ede had already begun to show his collection at Kettle's Yard in Cambridge from 1957, Nicholson tended to distribute his Wallises, especially on leaving St Ives in the following year. This ensured his importance to the younger artists, such as Denis Mitchell who was given *Schooner and Lighthouse* (fig.9).

In his memoir of St Ives, David Lewis described the alternative perceptions of Wallis as represented by Lanyon and Nicholson:

To Peter, Wallis was a Cornishman and his paintings were the language of an emotional and mystical oneness with the sea and ships, with lighthouses and cliffs … To Ben, Wallis was a painter … For Ben, the excitement of Wallis was in how alive and direct they were, and from them he learned the most difficult lesson of all, how to be unselfconscious and innocent while being true to the intensity and precision of experience.[30]

The work of every artist speaks to its enthusiasts in different ways which clearly reflect their expectations and needs. For Lanyon and Nicholson, Wallis represented the different qualities that they sought to instill in their own work; this was true of many others.

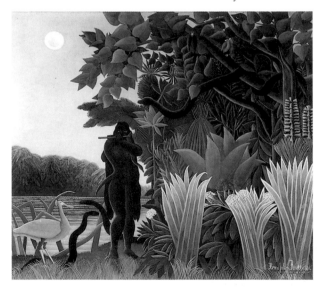

To be such a cipher is often the lot of an artist after his death, but for Wallis, as for others who were termed 'modern primitives', this was true during his lifetime. Concentrating on painting and geographically removed, he did not participate in the exhibition and publication of his work in the 1920s and 1930s. Perhaps it is unlikely that he would have been concerned about his role in the development of modernism. However, just as Wallis's painting techniques may now be seen as more than haphazard, so his categorisation as 'primitive' may be seen as too reductive. In his paintings he came to achieve a compositional subtlety in the balance and response to his materials. They were also able to convey complex ideas, allegorical as well as narrative, which did not arise by chance. At times he had been willing to discuss his work, but at others he closed the door on his privacy. When asked by Lanyon about one detail, he is reputed to have replied disarmingly: 'you mind your own business'.

Notes

KYA = Kettle's Yard Archive, University of Cambridge

Slack = Unpublished interviews recorded by Roger Slack in 1966; some broadcast in 1968 (BBC) and some transcribed in Edwin Mullins *Alfred Wallis: Cornish Primitive*, 1994

TGA = Tate Gallery Archive

Introduction

1 Ben Nicholson, 'Alfred Wallis' and Sven Berlin 'Alfred Wallis', *Horizon*, vol.7, no.37, 1943.

2 Sven Berlin, *Alfred Wallis: Primitive*, London 1949, reprinted Bristol 1992.

3 Edwin Mullins, *Alfred Wallis: Cornish Primitive Painter*, 1967; *Alfred Wallis*, exh. cat. by Alan Bowness, Arts Council 1968.

4 Peter Barnes, *Alfred Wallis and his Family; Fact and Fiction*, St Ives 1997.

5 Mullins 1967, p.14.

Chapter 1

1 Letters to Ede, 6 April 1935 and March 1937, KYA: AW 14, 38.

2 Stoke Damerel birth certificate.

3 Devonport census, 1851, Barnes 1997, p.5.

4 Penzance census, 1871, Barnes 1997, p.6.

5 Jacob Ward, step-grandson, Slack interview, in Mullins 1994, p.10.

6 Parish baptismal records: Jane Ellis, baptised 20 March 1819 at Sennen; Charles Wallis baptised 14 Dec. 1823 at Madron; Penzance Register Office marriage certificate, 6 July 1844, Barnes 1997, pp.4–5.

7 Berlin 1992, p.15.

8 Stoke Damerel birth certificate, Alfred Wallis.

9 Stoke Damerel birth certificate, Charles Wallis, 15 Feb. 1853 at 5 Market Lane, Devonport; Devonport census, Mary Wallis, 1851, Barnes 1997, p.5.

10 Berlin 1992, p.16, repr. pl.6.

11 Barnes 1997, p.5.

12 Death certificate, Jane Wallis, 13 Feb. 1866, aged 'about 44 years', at 51 Cannon Street, Devonport.

13 Ibid. and Devonport census, 1851, Barnes 1997, p.5; Berlin 1992, p.15.

14 Penzance census 1871, Barnes 1997, p.6.

15 Marriage certificate, Alfred Wallis and Susan Ward, 1876, and birth certificate, Alfred Charles Wallis, 1876, Barnes 1997, p.7.

16 Barnes 1997, p.7 Addendum.

17 Slack interview, Mullins 1994, p.10.

18 Albert Rowe, 'The Boy and the Painter', *Studio International*, vol.175, June 1968, p.293.

19 Madron Parish register 1879, and 1881 census, Barnes 1997, pp.7–8.

20 Berlin, p.29.

21 *'Bellaventur of Brixham Larbordoor Newfoundland Ice Burges'* (private collection), repr. Mullins 1967, p.42, fig.12.

22 Rowe 1968, p.293.

23 Berlin 1992, pp.18–19.

24 Philip J. Payton, *The Cornish Miner in Australia: Cousin Jack Down Under*, Trewirge 1984, p.177.

25 Barnes 1997, Appendix 2.

26 Death certificate, Charles Wallis, 29 March 1878, Barnes 1997, p.8.

27 Marriage certificate, 9 Dec. 1876, Barnes 1997, p.9.

28 Death certificate, Jacob Ward, died Madron 19 March 1872, Barnes 1997, p.6; Ward children, Barnes 1997, Appendix 4.

29 Marriage certificate, Alfred Wallis and Susan Ward, Barnes 1997, p.7 and Appendix 5.

30 Edwin Mullins, 'Alfred Wallis', BBC radio, 29 May 1968.

31 Birth and death certificates, Alfred Charles Wallis, 1876, and Ellen Jane Wallis, 1878, Barnes 1997, p.7.

32 Berlin 1992, pp.26–32.

33 Nancy Ward (Susan Wallis's daughter-in-law), Slack interview, broadcast in Mullins 1968.

34 Marriage certificate, Charles Wallis, 1876, Barnes 1997, p.9; Berlin 1992, p.36.

35 Barnes 1997, p.9 and in conversation.

36 *Kelly's Directory*, 1887 and 1891 Census, Barnes 1997, pp.9–10; Berlin 1992, p.37.

37 *Kelly's Directory*, 1902, Barnes 1997, p.11.

38 Slack interview, Mullins 1994, p.10.

39 Berlin 1992, p.40.

40 KYA: AW 6 verso.

41 Berlin 1992, p.40.

42 Mullins 1994, p.9.

43 Slack interview, Mullins 1994, p.10.

44 *St Ives Weekly Summary*, 25 Nov. 1893.

45 Ibid., 3 Feb. 1894.

46 Barnes 1997, p.10.

47 Berlin 1992, p.42; Barnes 1997, p.12.

48 Berlin 1992, p.42.

49 *Kelly's Directory*, 1910 but absent in 1914, Barnes 1997, p.12.

50 Rowe 1968, p.293.

51 Eddie Murt, *Downlong Days: A St Ives Miscellany*, St Ives 1994, pp.77–82.

52 Ibid., pp.78–9.

53 Deeds, 1908, Barnes 1997, p.12.

54 Barnes 1997, p.12.

55 Ibid.

56 Berlin 1992, p.49.

57 Rowe 1968, p.293; Mullins 1967, p.29.

58 Deeds, Barnes 1997, p.13.

59 Slack interview, Mullins 1967, p.26.

60 Berlin 1992, p.52.

61 Slack interview, Mullins 1994, p.12.

62 George Farrell, Slack interview, Mullins 1994, p.12.

63 Rowe 1968, p.292.

64 Mullins 1994, p.15.

65 Wallis, letter to Ede, 30 July 1938, KYA: AW 44.

66 Slack interview, broadcast in Mullins 1968.

67 Nicholson 1943, in Mullins 1967, p.110; Berlin 1992, p.85.

68 Sarah Langford, Slack interview, Mullins 1994, p.10.

69 Berlin 1992, p.73; Stanley Cock in conversation with author, Oct. 1996.

70 Murt 1994, p.61.

71 Frank Bottrell in conversation with author, Oct. 1996.

72 Berlin 1992, pp.73–5.

73 Berlin 1992, pp.70–1.

74 Wallis, letter to Ede, 23 March 1937, KYA: AW 37.

75 Berlin 1992, p.79.

76 Berlin 1992, pp.86–7.

77 Nicholson 1943, in Mullins 1967, p.110.

78 Barnes 1997, p.13.

Chapter 2

1 Murt 1994, pp.77–82; Jonathan Holmes, *St Ives Bay*, Stroud 1995, p.21.

2 Ben Nicholson, 'Alfred Wallis', *Horizon*, 1943 in Mullins 1967, pp.107–11.

3 Wood, letter to his mother, 5 Sept. 1928, TGA 773.5.

4 Wood, letter to Winifred Nicholson, 28 Oct. 1928, TGA 8618.

5 Ibid.

6 Wood, letter to Winifred Nicholson, [?29 Oct. 1928], TGA 8618.

7 Ede, letter to Ben Nicholson, 20 Oct. 1928, TGA 8717.1.2.842.

8 Wood, letter to Winifred Nicholson, 31 Oct. 1928, TGA 8618.

9 Wallis, letter to Ben and Winifred Nicholson, 17 Nov. 1928, TGA 8717.1.2.5264.

10 Wallis, letter to Ben Nicholson, 20 Nov. 1928, TGA 8717.1.2.5256.

11 *St Ives Times*, 2 March 1928.

12 Ede, letter to Ben Nicholson, [Dec. 1928], TGA 8717.1.2.847.

13 Wallis, letter to Ben Nicholson, 23 Nov. 1928, TGA 8717.1.2.5257.

14 Mullins 1967, pp.21–2.

15 F.W. Wallace, *In the Wake of the Wind Ships*, 1927, opp. p.5.

16 Wallis, letter to Ben Nicholson, 8 April 1929, TGA 8717.1.2.5261.

17 Ede, letter to Ben Nicholson, 13 Dec. 1928, TGA 8717.1.2.845.

18 Wallis, letter to Ben Nicholson, 28 Jan. 1929, TGA 8717.1.2.5260.

19 Ben Nicholson, letter to Wallis, 18 Feb. 1929, in Berlin 1992, pp.56–7.

20 Murt 1994, pp.80–1.

21 Wallis, letter to Ede, 24 April 1929, KYA: AW 1.

22 Mullins 1994, p.32.

23 Wallis, letter to Ben Nicholson, 23 June 1929, TGA 8717.1.2.5262.

24 Ede, letter to Ben Nicholson, 24 March 1930, TGA 8717.1.2.867.

25 *7 & 5 Society*, March 1929, annotated catalogue, Tate Gallery Library.

26 Helen Sutherland, letter to Ben Nicholson, 29 March 1929, TGA 8717.1.2.4699.

27 Unidentified press-cutting, quoted in Richard Ingleby, *Christopher Wood*, 1995, p.208.

28 Ben Nicholson, letter to Helen Sutherland, 10 Sept. 1932, Helen Sutherland papers, on loan to TGA.

29 Lucy Carrington Wertheim, *Adventure in Art*, 1947, p.84.

30 Wallis, letter to Ben Nicholson, 6 June 1933, TGA 8717.1.2.5265.

31 Wallis, letters to Ben Nicholson, 23 April and 5 May 1934, TGA 8717.1.2.5266, 5267.

32 Wallis, letter to Ede, 23 July 1936, KYA: AW 30.

33 Wallis, letter to Ede, 9 Feb. 1934, KYA: AW 2.

34 Wallis, letter to Ede, 10 June 1936, KYA: AW 26.

35 Wallis, letter to Ede, 14 Sept. 1934 KYA: AW 7.

36 Wallis, letter to Ede, 8 Jan. 1935, KYA: AW 11.

37 Wallis, letter to Ede, Jan. 1935, KYA: AW 12.

38 Wallis, fragmentary letter to Ben Nicholson, [?1935], TGA 8717.1.2.5268.

39 Wallis, letter to Ede, 30 Nov. 1935, KYA: AW 21.

40 Wallis, letter to Ede, 1 April 1936, KYA: AW 23.

41 Wallis, letter to Ede, 4 Nov. 1936, KYA: AW 36.

42 Wallis, letter to Ede, 23 March 1937, KYA: AW 37.

43 Wallis, letter to Ede, 27 July 1938, KYA: AW 44.

44 Herbert Read, 'L'Art Contemporain en Angleterre', *Cahiers d'Art*, no.1–2, 1938, p.33, repr. as 'Peinture'.

45 Wallis, letter to Ede, 30 July 1938, KYA: AW 45.

46 Wallis, letter to Ede, 14 Aug. 1938, KYA: AW 46.

47 Wallis, letter to Ede, 6 July 1939, KYA: AW 48.

48 Stokes, letter to Ben Nicholson, 8 March [1949], TGA 8717.1.2.4562.

49 Wilhelmina Barns-Graham interview in Peter Davies, 'Notes on the St Ives School', *Art Monthly*, no.48, July–Aug. 1981, p.5.

50 Stokes, letter to Ben Nicholson, 8 March [1949], TGA 8717.1.2.4562.

51 Ben Nicholson, letter to Ede, 29 Aug. 1942, KYA.

CHAPTER 3

1 Nicholson 1943, in Mullins 1967, p.107.

2 Wallis, letter to Ede, 2 Aug. 1935, KYA: AW 17.

3 Nicholson 1943, in Mullins 1967, p.107.

4 *Tate Gallery Catalogue of Acquisitions 1974–6*, 1978, p.163.

5 *Sailing Ship with Lighthouse*, repr. Mullins 1967, fig.59.

6 *Seven Boats Entering Harbour*, Kettle's Yard, University of Cambridge, AW 7.

7 Ede, letter 12 July 1959, Tate Gallery catalogue files.

8 Wallis, letter to Ede, 24 April 1929, KYA: AW 1.

9 Ede, letter to Ben Nicholson, [?early 1929], TGA 8717.1.2.849.

10 Wallis, letter to Ben Nicholson, 20 Nov. 1928, TGA 8717.1.2.5256.

11 Ben Nicholson, letter to Ede, 6 June 1949, KYA.

12 Ede, 'Two Painters in Cornwall', *World Review*, March 1945, p.46.

13 Untitled landscape, repr., *St Ives 1939–64*, exh. cat., Tate Gallery 1985, p.153, no.13.

14 Mullins 1967, pp.66–7.

15 Herbert Read, *Unit 1: The Modern Movement in English Architecture, Painting and Sculpture*, 1934, p.90.

16 Hepworth, letter 10 Feb. 1969, Tate Gallery catalogue files.

17 Wallis, list sent to Ede

possibly with letter dated 12 Feb. 1934, KYA: AW 4.

18 Joseph James Laity's memoir, MS., collection Harding Laity.

19 Nicholson 1943, in Mullins 1967, p.109.

20 Hepworth, letter to Ben Nicholson, 20 Dec. 1932, TGA 8717.1.1.117.

21 Wallis, letter to Ede, 1 April 1936, KYA: AW 23.

22 Albert Rowe, 'The Boy and the Painter', *Studio International*, vol.175, June 1968, p.293.

23 *P & O Boat*, Kettle's Yard, University of Cambridge, AW 37.

24 *St Ives 1939–64*, exh. cat., Tate Gallery 1985, p.155.

25 Mullins 1967, pp.92–4.

26 Murt 1994, pp.33–4, 43.

27 Wallis, letter to Ede, 1 April 1936, KYA: AW 23.

28 Mullins 1967, p.21.

29 *St Ives Times*, 4 Feb. 1938.

30 Wallis, letter to Ede, 30 July 1938, KYA: AW 45.

31 Sheila Lanyon, letter to the author, Feb. 1997.

CHAPTER 4

1 Interview, broadcast in Edwin Mullins, 'Alfred Wallis', BBC radio, 29 May 1968.

2 Berlin 1992, p.9.

3 Ibid.

4 William Blake, *Death's Door*, 1805 for Blair's *Grave*.

5 See Jeremy Lewison, ""Primitivism" and Landscape', in *Ben Nicholson*, exh. cat., Tate Gallery 1993, pp.31–6, and Charles Harrison, 'The Modern, the Primitive and the Picturesque', in *Alfred Wallis, Christopher Wood, Ben Nicholson*, exh. cat., Pier Arts Centre, Stromness 1987.

6 *Cedric Morris*, exh. cat., Tate Gallery 1984, ed. by Richard Morphet, p.91.

7 Wood, letter to Winifred Nicholson, 31 Oct. 1928, TGA 8618.

8 'Le Douanier Rousseau', *Les Soirées de Paris*, 15 Jan. 1914, trans. in Leroy C. Breunig ed., *Apollinaire on Art*, New York 1972, p.349.

9 *Douanier Rousseau*, Lefevre Gallery, 1926; *The Sleeping Gypsy* 1897, Museum of Modern Art, New York.

10 Ferdinand 'Le Facteur' Cheval (1836–1924), Séraphine Louis (1864–1934), André Bauchant (1873–1958).

11 E.g. Yvangot, 'Art Maritime: Les "Ex-Voto" des marins', *Cahiers d'Art*, no.4–5, 1927, cited in *Ben Nicholson*, exh. cat., Tate Gallery 1993, pp.33–4.

12 Hans Prinzhorn, *Bildnerei der Geisteskranken*, Berlin 1922, trans by E. von Brockdof as *Artistry of the Mentally Ill*, Berlin 1972.

13 David Maclagan, 'Outsiders or Insiders?' in Susan Hiller (ed.), *The Myth of Primitivism: Perspectives on Art*, 1991, p.33.

14 Stokes, letter to Ben Nicholson, 8 March [1949], TGA 8717.1.2.4562.

15 Herbert Read, *Art Now*, 1933, revised 1936, pp.45, 46.

16 Ibid., p.123.

17 Herbert Read, 'L'Art Contemporain en Angleterre', *Cahiers d'Art*, no.1–2, 1938, p.31 (my translation).

18 Adrian Stokes, *Colour and Form*, 1937, p.64.

19 Ibid.

20 *Masters of Popular Painting*, exh. cat., Museum of Modern Art, New York 1938, p.15.

21 Lucy Carrington Wertheim, *Adventure in Art*, 1947, pp.37, 50, 52.

22 *Art by the People*, n.d. [?1938].

23 *Unprofessional Painting*, Bensham Grove Settlement, Gateshead, Oct. 1938, p.1; see also William Feaver, *Pitmen Painters: The Ashington Group*, 1988.

24 Ibid., p.2.

25 Sidney Janis, 'Contemporary American Primitive Painting', *Horizon*, vol.9, Jan. 1944, p.24; *Unknown American Painters*, Museum of Modern Art, New York 1939, *Morris Hirshfield*, Museum of Modern Art, New York 1943.

26 Nicholson 1943 in Mullins 1967, p.108.

27 Ibid., pp.110–1.

28 Wilhelmina Barns-Graham interview in Peter Davies, 'Notes on the St Ives School', *Art Monthly*, no.48, July–Aug. 1981, p.5.

29 Sven Berlin, 'Alfred Wallis', *Horizon*, vol.7, no.37, 1943.

30 David Lewis, 'St Ives: A Personal Memoir, 1947–55', in *St Ives 1939–64*, exh. cat. Tate Gallery 1985, pp.20–1.

Select Bibliography

BEN NICHOLSON, 'Alfred Wallis', *Horizon*, vol.7, no.37, 1943; republished in Mullins 1967.

SVEN BERLIN, 'Alfred Wallis', *Horizon*, vol.7, no.37, 1943.

SVEN BERLIN, *Alfred Wallis: Primitive*, London 1949 and Bristol 1992.

EDWIN MULLINS, *Alfred Wallis: Cornish Primitive Painter*, London 1967.

ALAN BOWNESS, *Alfred Wallis*, exh. cat. Arts Council of Great Britain 1968.

ALBERT ROWE, 'The Boy and the Painter', *Studio International*, June 1968.

DAVID BROWN, *St Ives 1939–64*, exh. cat. Tate Gallery 1985, republished 1996.

CHARLES HARRISON and MARGARET GARDINER, *Alfred Wallis, Christopher Wood, Ben Nicholson*, exh. cat. Pier Arts Centre, Stromness 1987.

ST IVES, exh. cat., Setagaya Art Museum, Japan 1989.

GEORGE MELLY, *A Tribe of One: Great Naive Painters of the British Isles*, Yeovil 1981; section on Wallis republished in *Alfred Wallis: Paintings from St Ives*, Cambridge 1990.

EDWIN MULLINS, *Alfred Wallis: Cornish Primitive*, London 1994.

KETTLE'S YARD AND ITS ARTISTS: AN ANTHOLOGY, Cambridge 1995.

PETER BARNES, *Alfred Wallis and his Family: Fact and Fiction*, St Ives Trust Archive Study Centre 1997.

Credits

Index